AIRBRUSHING

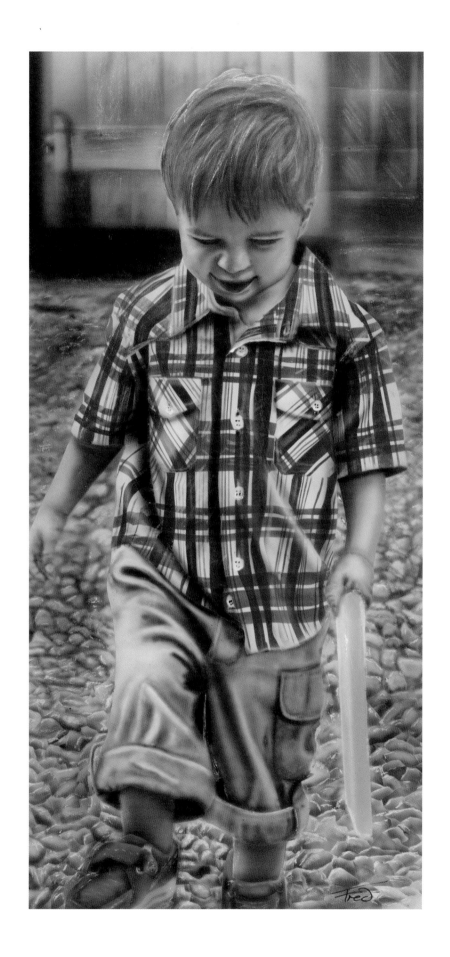

AIRBRUSHING
THE ESSENTIAL GUIDE

Fred Crellin

THE CROWOOD PRESS

First published in 2013 by
The Crowood Press Ltd
Ramsbury, Marlborough
Wiltshire SN8 2HR

www.crowood.com

Paperback edition 2022

British Library Cataloguing-in-Publication Data
A catalogue record for this book is available from the British Library.

ISBN 978 0 7198 4134 7

Frontispiece: *Finlay's Frisbee* by Fred Crellin: liquid acrylic onto artboard. 20cm x 45cm approx.

Acknowledgements
I had been promising to write a book about airbrushing for years, so this has only come about
with the help, support and contributions from the following people: Andy Penaluna for his
knowledge, enthusiasm and encouragement; Pam Cartwright, my old art teacher when I was at
school, for helping me realize my love for art; Andy Hay for his pictorial contributions; Rosemary
and Ken Medwell for their help with the historical chapter; former students of the Artimagination
Airbrush School, who have each helped in their own little way; and finally my wife Ginny and my
children for their patience and not seeing me for days on end when I disappeared to my studio
to write this book. All photos and pictures (graphics) are by Fred Crellin, except where specified.

Cover design by Maggie Mellett
Typeset by Sharon Dainton Design
Printed and bound in India by Parksons Graphics Pvt Ltd.

Contents

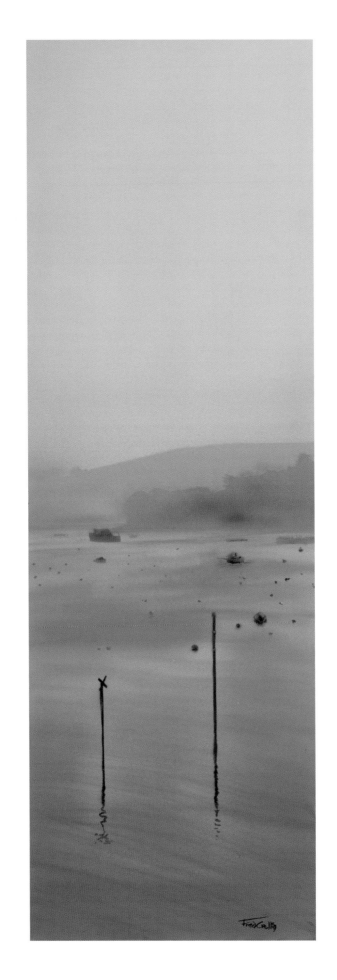

Foreword

I was reminded in a corridor conversation the other day that many people now think of airbrushing as relatively new phenomenon – and that it is achieved on a computer. Sadly, they have missed the joys of the airbrush as an art form in the physical sense. It is true to say that as it never actually touches the paper or work surface, airbrush has always been on the grey edge of artistic acceptability. How can you make marks on the paper or surface if you never touch it? How can you get the feel of your work?

To those who airbrush the joys are well known – as well, of course, as the trials and tribulations of managing the instrument itself. The airbrush student has to learn significant new skills: to master not only colour and shade, but also air pressure, paint consistency and the diverse ways of masking and shading that can help to achieve such wonderful results. Correcting errors can be particularly difficult and frustrating, so I always think that it takes a special type of person, someone who has the patience and determination the medium demands.

Again, it also needs a special kind of teacher and that is why I have loved working with Fred Crellin. Back in the 1970s when I first started out there were many specialists around. Now they are few and far between, so their knowledge and skills have special value. This book is sorely needed; it takes what Fred does in the studio and places it in one accessible and easy to understand volume. I hope you have fun with it, and that you too get to feel that special thrill of seeing a work to be proud of at the end of your airbrush.

Professor Andy Penaluna – PhD 'Doc' of airbrush history

LEFT: *Misty Morning* by Fred Crellin: liquid acrylic onto canvas. 20cm x 80cm approx.

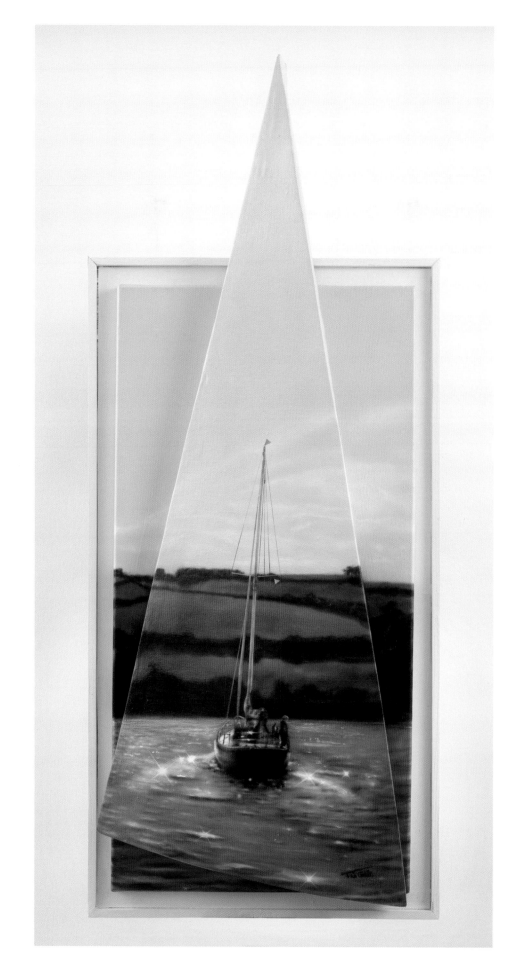

Introduction

Airbrushing books are generally quite hard to find. Airbrushing itself has always been such a specialized area of art and design, that there have been very few people with the knowledge and skills to convey how to use, let alone maintain, an airbrush correctly. I have only come across perhaps two books from the last thirty years that have gone to any great length to explain how the tool actually works and have shown how to maintain the tool. There have been dozens of books published that show the reader how to create wonderful pieces of artwork with some eye-opening techniques. However, none explain what to do if things go wrong, or cover fundamentals such as what sort of paint to use.

My intention in this book is to remove any fear of the airbrush and explode the myths surrounding it. In society, the very word 'airbrush' is generally used in negative terms. This usage of the word does the tool itself an injustice. Although a high precision tool, it is a simple device used to deliver pigment or paint onto a surface as an atomized mist, enabling the user to quickly create remarkable colour blending with the greatest of ease.

Added to this, the airbrush can be used in so many different applications. It is a wonder why so few art colleges use the tool as it is applicable in fine art, illustration, textiles, photography, fashion design, 3D model making, cake decorating, make-up.... the list is endless. From personal experience, most schools and colleges do not use airbrushes regularly because the teachers believe the device to be expensive, complicated and unreliable. This is only true if it is put in the hands of the uneducated user. This book, I hope, will educate everyone into the wonderful flexibility the airbrush offers and, more importantly, that the tool is none of the negatives mentioned. It is a highly rewarding and, dare I say, addictive method of creativity. The airbrush is not a temperamental magic wand; it's just a tool. Granted, it's a high precision instrument, but with a little knowledge, understanding and help, it is a device that will deliver detail and finesse anyone can achieve with just a little practice and know-how.

At the time of writing this book, I have been airbrushing for some twenty-five years. Although largely self-taught, in that time I have made just about every mistake there is to make, but most importantly, I have learned from them. As a qualified teacher, I understand that learning from your mistakes is a great way of learning. However, making mistakes, as I also found out, can be costly. In this book I have set out to inform the reader and help them avoid making too many costly mistakes and save time, money and sanity.

Airbrushing is very much a learned technique, just like riding a bike. The latter chapters of this book are written as a 'how to' guide, where I demonstrate a multitude of techniques and show these on different surfaces.

The nuts and bolts aspect takes you through which airbrush to buy from the range that is available to how to maintain and look after the tool. When things go wrong, there is a chapter that helps you identify and solve the problem. There is also a chapter on tools and equipment, highlighting and separating the essential tools from the desirable.

Once the basic fundamentals of how to look after your airbrush and getting started have been covered, the remaining chapters cover a wide range of applications. The versatility of the airbrush enables the user to tackle any number of projects, from fine art and custom painting to painting 3D models and cake decorating, all of which are covered in this book.

Throughout, I will offer the reader 'pearls of wisdom' in the form of a 'tip' where basic knowledge in its simplest form will go a long way in enlightening and educating the reader into the finer points of airbrushing.

Although this book does not cover airbrushing in all its many applications, especially as new ones are being discovered every year, the vast majority of applications are discussed, especially the mainstream ones. Primarily, the techniques that are used in conjunction with the airbrush can be transferred to multiple uses, even if the technique used in the book is used on a specific application.

As an educator, I hope you find this book useful and enlightening, and that it builds and drives for you a passion that I have for a specific form of creativity... airbrushing.

LEFT: *Normandy Pontoon 3D* by Fred Crellin: liquid acrylic onto 3D canvas. 50cm x 100cm.

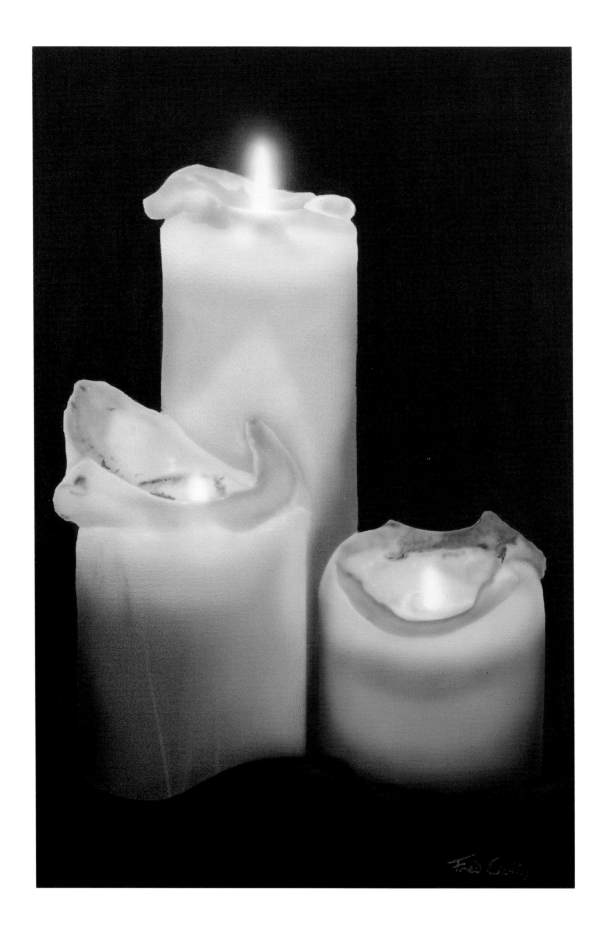

Fred Corley

Chapter 1
The history and development of the airbrush

For many years the history of the airbrush consisted of a series of muddled and incorrect bits of factual information, put together to make some kind of coherent sense. It was not until the 1990s that the true history of the airbrush was properly researched and verified. This extensive research was conducted by my friend Professor Andy Penaluna, to whom I owe much of the credit and thanks in being able to write this chapter. This is the first time, I believe, that the correct information and unabridged history has been published.

The origins of paint spraying

Paint spraying, in all its many forms, has been around for thousands of years. Examples of the very earliest forms of this can be found in the caves of Lascaux in France. It is believed that 'cavemen' from the Palaeolithic era used hollowed out bones filled with animal blood to create some of the images seen on the cave walls, created over 17,000 years ago. Physically blowing the blood out from the centre of the bone onto the wall, using their own hand as a template, was a rudimentary but

effective method of signing their work.

However, further caves were discovered in Spain and Portugal that showed an advance in the techniques used. At caves discovered in Altamira in Spain and Côa in Portugal, paintings were uncovered that showed greater definition and detail in the pigmentation being used. Added to this, remains of the actual tools used to create them were also discovered, and have been dated to around 13,000 BC. The technique is still in existence today and used in schools with the aid of what is referred to as a

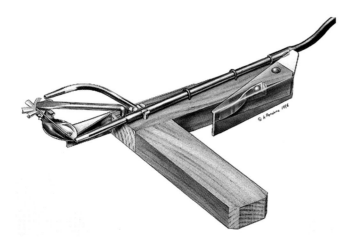

Andy Penaluna created this image of an early forerunner of the airbrush using the actual tool depicted, as living proof that this odd-looking 'airbrush' actually works. It was created using a combination of needle, rubber and brass tubes, screwdriver and a bent spoon. (© Andy Penaluna)

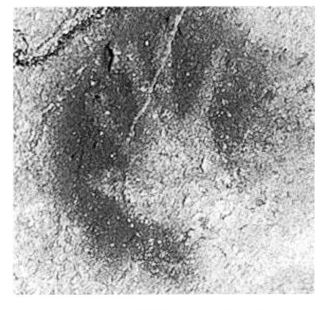

A hand print created over 17,000 years ago. (Photo: John Berry)

LEFT: *Together* by Fred Crellin: liquid acrylic onto box canvas, 40cm x 80cm.

Palaeolithic man used hollowed out bones filled with blood to create wall art in caves.

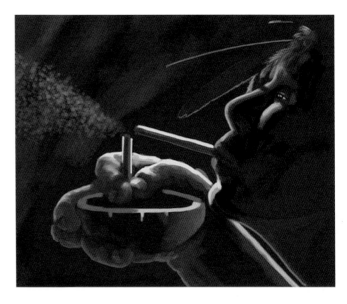

A more sophisticated method of atomizing pigment, from around 13,000 BC. (www.visioninconsciousness.org)

Two smaller hollowed out bones are used like a diffuser. (http://flickrhivemind.net/Tags/art,rupestre/Interesting)

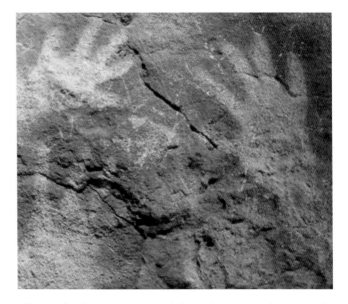

The results shows greater detail through creating a finer mist of pigment.

diffuser.

This method of applying dye or paint may have existed in numerous forms for various applications until the nineteenth century. It was the advent of photography that got things going in the right direction. At around this time, portraits became very popular, as quick photos could be taken, prints enlarged and then reproduced by artists using the photo as a guide to the likeness of the client. Many worked directly on top of this print, often using chalks and pastels. However, with the development of paint spraying tools, this was to change

significantly.

Even after extensive research, there is still some debate as to who can be credited with designing the first 'airbrush' tool. This is primarily to do with the exact definition of an airbrush: is it a tool that has to be physically blown into, have a squeezable ball where a puff of air is emitted, or a constant flow of compressed air?

In 1876 Frank E. Stanley patented a 'paint atomization' device. His device did not use a regular, compressed form of air, but instead relied on a squeezable 'puff' blower. Frank E. Stanley was an award-winning American artist from Kingfield, Maine. His invention was for a device that was able to 'spray water colours, India-ink and also for all kinds of shading in which colour can be used in a liquid state.' Today, its basic design is not dissimilar to the mechanism found in perfume bottles, but at the time his design had a perfect application in photo retouching. His additional design features allowed the user greater control over volume and quality. Because it was 'powered' by a puff blower, it can be argued that in the true sense of the definition of what an airbrush is, this should not be regarded as an airbrush, but as its immediate forerunner. However, within three years (and 1,500 miles away), Abner Peeler was inventing a completely different way of atomizing paint, in conjunction with an air compressor device that powered the tool with a constant source of compressed air.

The dawn of airbrushing

It was around 1879 that Abner Peeler, an eccentric jeweller from Iowa in the USA, conducted various experiments. Using compressed air that was pumped by hand (or more specifically foot), jam spoons and needles, he came up with the design for a 'paint distributor', and

A design for a paint atomizer from around 1876, which used a squeezable 'puff' ball as its air source. (Courtesy Stanley Museum, Kingfield, Maine, USA ©)

began on a journey that was to develop into the tool we use today.

Peeler is regarded by many as the creative genius behind the initial development of the airbrush. His initial paint distributing device was just one of his many patented inventions. However, being an eccentric jeweller and part-time inventor, his motive lay in the designing of new devices; making money and spending time developing an idea were never really motivating factors to him. He was no businessman and sold his first design prototype of the paint distributor for a mere $10, but later sold the patent for $700 to the Walkup brothers – quite a lot of money back in 1882. Peeler can also be credited with the invention of a form of typewriter, twenty years prior to the recognized patented design, as well as dozens of other designs, including a form of foot-operated compressor.

In the three years from 1882, Charles and Liberty Walkup invested in the development of the tool, which culminated in the manufacture and sale of a small number of these new paint distributors at a Philadelphia Photographic convention. Eventually the

Frank E. Stanley. (www.mainememory.net)

Abner Peeler. (Courtesy Stanley Museum, Kingfield, Maine, USA ©)

Walkup Brothers set up the aptly named Airbrush Manufacturing Company, which began worldwide distribution of the tool.

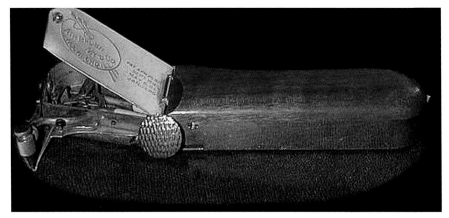

The first patented airbrush paint atomizing device from 1884.
(© Andy Penaluna)

The birth of the airbrush

The Airbrush Manufacturing Company developed into a business that would distribute worldwide. At precisely 7pm on 6 October 1883 a meeting was called in the offices of local attorney William Lathrop. Following a vote the Rockford Manufacturing Company changed its name to the Airbrush Manufacturing Company and the name 'airbrush' was officially born. When the company was formed, $35,000 of stock was raised in the first half hour and a further $15,000 by the second day! With this level of financial business support Liberty Walkup was able to start developing and seriously marketing the airbrush.

Unlike Abner Peeler, Liberty Walkup saw the potential of the paint distributor. With his brother Charles' money, his wife Phoebe's artistic skills, and his own ability to promote, he was able to develop the tool into a highly profitable and marketable product. Peeler signed over the invention to them in April 1882 after further development and it was then marketed by himself and his wife at various shows including a photography convention in Indianapolis in August 1882. There they sold sixty-three paint distributors.

By 1885 production of the airbrush

was at its peak and Liberty Walkup was able to start marketing and selling his new and much refined single trigger design.

Small classes were set up to teach people how to use this new art tool but demand became so great that within three years the Illinois Art School was formed to accommodate all the interested students.

However, it was at Chicago's Columbian Exposition in 1893 that there were suddenly two different types of airbrushes being exhibited. Charles Burdick had seized upon the Walkup 'Airbrush', and through successive developments that initially simply encased Walkup's design within a pen-shaped case, he re-designed it to be more like a pen, lighter and sleeker in design. Unlike the Walkup model, which had an oscillating needle driven by air, Burdick's design consisted of a needle and nozzle housed within a metal tube.

Charles Burdick came from a family of designers and inventors, and over his life filed many patents. However, he is widely regarded as the man who invented the airbrush, especially the form that we are familiar with today. His design, born over 120 years ago, in collaboration with his friend Dr Allen

DeVilbiss who patented medical throat sprays, included a centralized needle control system. It is believed that he studied the use of atomizers, such as that by Frank E. Stanley, while developing his airbrush. Shortly after designing the tool, Burdick moved to England and set up The Fountain Brush Company in London, which shortly changed its name to the Aerograph Company. Not long after that, Burdick joined forces with Allen DeVilbiss to become DeVilbiss Aerograph, which existed for nearly the whole of the twentieth century.

At this point in history, the airbrush was now being taken up and developed by a number of individuals and companies.

The Illinois Art School was founded as a result of the popularity of the airbrush. (© Andy Penaluna)

Charles Burdick.
(Courtesy of Sergej Voronko,
http://airbrushdoc.com/history/airbrush-
charles-burdick)

Olaus Wold, one of the first twentieth-
century airbrush pioneers.

Olaus Wold was one such individual who assisted Burdick in the fabrication of prototype models. As a craftsman, Wold had an intimate knowledge of how Burdick's airbrush worked. By 1896, he had begun improving the design and patented these under his own name. He approached Thayer and Chandler, a Chicago-based Arts and Crafts mail order company, for whom Wold worked as a foreman, to produce and market his airbrush. Fellow Norwegian Henry Thayer was happy to support Wold in his development of the airbrush, which went on to become one of the most respected brands of airbrush for decades to come. Although Wold was the mastermind behind the improved designs, such as the inclusion of an aircap that protected the needle and other improvements to the nozzle to prevent clogging, Thayer and Chandler remained the owners of the patents. The company flourished and eventually dropped all its other art materials with the exception of airbrushes. It eventually closed its doors in 1999, being sold to Badger Airbrushes, another well recognized airbrush manufacturer.

Olaus Wold did eventually leave Thayer and Chandler three years later in 1899 to set up the Wold Airbrush Company. Without the advertising and financial backing that other airbrush manufacturers had, his brand was not as well recognized as other new manufacturers in the development of the tool, such as Jens Paasche.

The young Jens Paasche was another foreman with Thayer and Chandler and had worked closely with Wold. He also gained important knowledge as to how the tool worked, but perhaps did not show the same loyalty to Thayer and Chandler that Wold showed. By 1904, the ambitious young Norwegian was fascinated with the Walkup design, tinkering and improving the oscillating needle design that had been around for

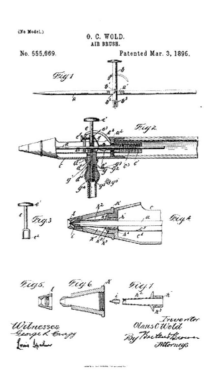

Wold spent several years developing and improving the performance of his airbrushes with additions, such as an aircap that protected the needle. (Courtesy Stanley Museum, Kingfield, Maine, USA ©)

twenty-five years. With financial backing from his brother Olaf, the Paasche brothers set up the Paasche Airbrush Company in late 1904. Jens concentrated on designing various types of airbrush, such as the single action, external mix type of brush. His initial design, based on the Walkup model, became eventually known as the Paasche AB turbo, a model that is still in production today, and still regarded as one of the finest models in production, giving the user the ability to paint some of the finest details possible.

During the 1920s and the advent of the motor car, the use of the airbrush changed from a photo-retouching tool to something that could be used for more

Jens Paasche began manufacturing his own airbrushes in 1904. (www.airbrushmuseum.com)

graphic designs and illustrations. Artists such as Alberto Vargas and George Petty glamorized the airbrush with their depictions of the female form in an elegant style. It was this new-found application that led to various new manufacturers around the world beginning to manufacture their own models. Friedrich Boldt established EFBE Airbrushes in 1919 in Germany, with Iwata in Japan following suit. The Japanese company spotted the versatility of the tool in the 1920s and began manufacturing spraying equipment in 1927, closely followed by the manufacture of a compressor a year later. Iwata now leads airbrush development and manufacture by using high quality materials and manufacturing processes, as well as aggressive marketing and advertising, a marketing model favoured by Paasche in the early half of the twentieth century.

After the end of the Second World War, two more companies began manufacturing new designs: Harder & Steenbeck in Germany changed their production of electrical components to

airbrush manufacture, and are now one of the most respected brands today. The other company, Connor Patents Ltd in England, produced the Conograph, and latterly the Conopois airbrush up until the 1980s. The popularity of the hand-made Conopois airbrush alerted Rotring who looked to add this airbrush to their portfolio of graphical equipment and duly purchased the design. The Rotring Conopois airbrush remained in production for a further decade until the early 1990s.

Badger Airbrush was set up as an Anglo-American company in 1963 when airbrushing in the commercial illustration field had reached a new high. The rock and pop music industry, together with vehicle customization, saw the airbrush reach new heights of popularity as an essential tool in commercial illustration for magazines, album covers and t-shirt painting. Designed by Welshman Jan Ilot, the last revolutionary re-design of the airbrush came about in the late 1980s as the 'Aztek' (the Aztek name is derived from the A to Z of Technology). The Testors®

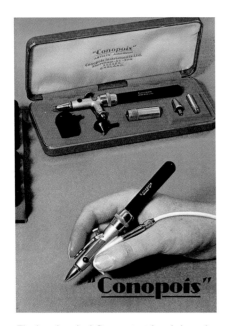

The hand-crafted Conopois airbrush from the 1950s. (Courtesy of Rosemary and Ken Medwell, The Airbrush Company, Lancing©)

Harder & Steenbeck airbrushes offer precision engineering typical of German manufacture. (Courtesy of Harder & Steenbeck ©)

Corporation, which started out as a subsidiary of Kodak (note the photographic connection), bought the design and began producing two models of airbrush primarily made of solvent-resistant plastic. Their first model, the 1000S, was a simplified version of the Conopois airbrush. Their other design, eventually becoming the A430 and A470 models, offered the user a unique but simple interchangeable nozzle system.

However, by the beginning of the 1990s, the whole airbrush industry began to struggle with the advent of

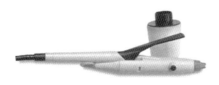

The Aztek 1000S airbrush with its revolutionary plastic moulded body. (Courtesy of the Testors ® Corporation ©)

digital technology. Instead of the tool being an integral part of a design studio, the airbrush has become regarded as a versatile tool in a niche market area. Although it is unlikely that its use will ever reach the heights of the 1970s and 1980s, new uses for the airbrush have been discovered and experimented with, such as the application of make-up and for cake decoration. Some of these will be covered in further chapters in this book, or referred to in the chapters dedicated specifically to practical uses of the airbrush in the workplace. Manufacturing techniques have also improved greatly in the last two decades. This has led to the mass production of cheaper airbrushes, which are generally produced in the Far East and regarded by many as a 'disposable' tool, since cheaper materials are now used in production to keep costs down.

The future of airbrushing

In our computerized and digital age, the airbrush as a tool will continue to be further marginalized as new technology and techniques continue to develop. However, for those who use a 'real' airbrush, what will remain is the connection between human skill and our ability to control and master the art of airbrushing. Just like the appreciation of traditional arts and crafts, airbrushing will be appreciated as an art form in itself: living proof that an individual can produce perfection without the aid of modern digital technology. There will always be a place, no matter how small, for an individual to learn how to control and master this wonderful and versatile tool, and for others to appreciate their endeavours.

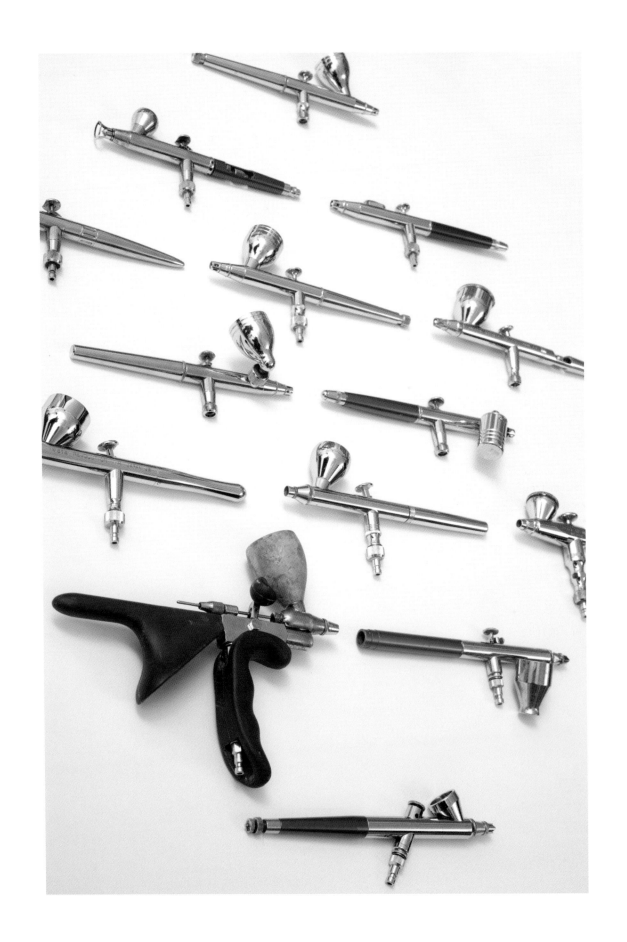

Chapter 2
Choosing and maintaining your airbrush

2

Types of airbrush

The basic principle behind all forms of airbrush is the same: a compressed air source is fed through the implement, drawing a medium (paint) through it as it passes through a small aperture. The actual control of the air and paint, however, can vary from airbrush to airbrush, depending on the type or model. Its performance regarding paint atomization can also vary, as can paint and air volumes. The question is, with all these variables to consider, what sort of airbrush is best for you?

This will largely be determined by the type of work you intend to do most frequently, and the type of control that works best for you. What works for one person may not necessarily work for another. Using the motor car as a comparison, the airbrush can be controlled either as a manual or an automatic, or even a semi-automatic. A two-seat sports car will carry only one passenger and enough luggage space for a handbag, but will get you there faster; on the other hand, a family car will offer more than two seats, get you there in reasonable time and offer more than enough storage space for a suitcase or two.

Similarly, if you intend to work on a large scale, there is little point having an airbrush with only a very small nozzle and small paint reservoir. Manufacturers follow several trains of thought in order to produce airbrushes that will suit every individual's needs. Some manufacturers are of the opinion that each airbrush should be used specifically for a particular job. They believe that if you want to achieve large area coverage, and then rework over the top of your work in the finest detail, then two different airbrushes should be purchased specific to the job required. However, other manufacturers believe that having flexibility within one airbrush to do multiple jobs with an interchangeable nozzle system will suit some customers. They will also incorporate a degree of 'self customization' of the airbrush, offering additional features that can be purchased as an additional product. There is also the last bracket of manufacturers who produce the airbrush as a very cheap, low quality, disposable tool, designed to be used only a few times before it fails to function correctly.

To begin with, let us look at the main types of airbrush available. Airbrushes fall into two main categories: single-action and double-action.

Single-action airbrushes

The single-action airbrush offers the simplest airbrushing: a trigger is pressed for air, while a needle is set in a specific position to determine the volume of paint. Those setting out in airbrushing for the first time, such as beginners or even young children, will find this type of control easier to manage. This type of airbrush is often used by modellers, or by those not necessarily needing to achieve highly detailed work. Single-action airbrushes can be used effectively if your work includes masking, shields or stencils.

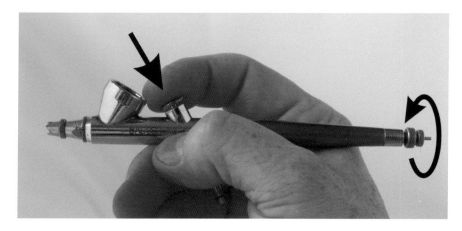

The single action airbrush. Simply adjust the wheel at the back to create the desired volume of paint, then depress the trigger for air.

LEFT: Various models and styles of airbrush.

Double-action airbrushes

Double-action airbrushes as a category can be split into two types: independent double-action or fixed double-action. Either way, the trigger is pulled back to allow the desired quantity of paint. Unlike the single action where the needle is pre-set and fixed in position by the user to achieve the correct volume of paint, the double-action gives the user the freedom to choose exactly how much paint volume they require by altering the trigger position backwards and forwards.

The variation between the two types of double-action comes with how the air is introduced.

FIXED DOUBLE-ACTION AIRBRUSHES
These airbrushes work on exactly the same principle as a common spray gun. The trigger is pulled back to introduce air, and then pulled back further to include paint into the mix from the nozzle. The desired amount of paint, as already mentioned, is determined by how far back the trigger is pulled back.

INDEPENDENT DOUBLE-ACTION AIRBRUSHES
Widely regarded as the professional's choice of airbrush, its trigger action gives the user instant and total control over air and paint. However, some

practice and coordination is needed to fully control and appreciate this type of tool. The mechanism itself works on the same principle as the fixed double action, with the exception that to introduce air the trigger is pushed down. The trigger action is controlled entirely with the index finger, and dexterity is required to press down and then pull back to achieve just the right amount of paint needed.

Internal mix and external mix airbrushes

The most common type of airbrush is the internal mix airbrush. This description of an airbrush refers to whether the nozzle of the airbrush is within the airflow (air cap), or external from it. As a generalization, external airbrushes tend to be the cheaper, hobbyist types, as they offer little in the way of quality paint atomization and little ability to gain any detail. External mix airbrushes tend to be used for applying flat colour or basic colour fades, and are most frequently used in modelling and textile pattern design.

It is the internal mix airbrush that is most commonly recognized as providing a good quality spray. The paint is atomized at the tip, in line with the air flow. Internal mix airbrushes also allow for much finer needles and nozzles to be

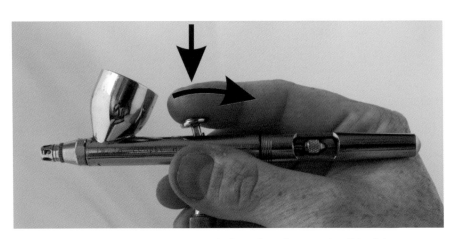

Most fixed double-action airbrushes will have some form of paint limiter on the back. The trigger is pulled back for air, then further back for paint.

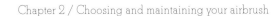

The independent double-action airbrush. Press down for air and pull back for paint.

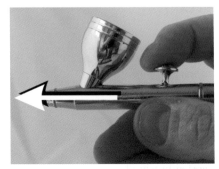

The nozzle lies inside the aircap of the front assembly.

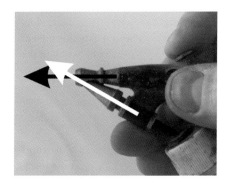

External mix airbrushes have the nozzle and air separated.

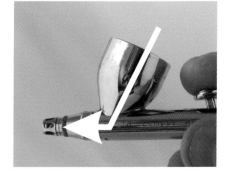

Gravity-fed airbrushes draw paint down into a paint cup.

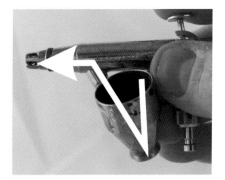

Suction-fed airbrushes pull paint up through a tube or line.

designed and fitted within the main body of the airbrush.

Suction- (siphon-) fed and gravity-fed airbrushes

Whether an airbrush is suction-fed or gravity-fed will depend on where the paint supply is drawn from. If it is drawn from above the nozzle, then it is a gravity-fed airbrush.

If the paint is drawn from below, through a tube, then it is a suction-fed airbrush.

Choosing which of these two formats to use entirely depends on what type of work you do, as well as how you prefer to work. It is generally assumed that having a larger cup size enables the user either to use one colour frequently, or have an ability to paint larger areas without regular refills of paint. There is an argument that using a suction-fed system is quicker than using a gravity-fed system. This would be true only if the user had numerous airbrushes, each with its own dedicated colour pot permanently attached. Artists that specialize in T-shirt painting and airbrushed tattoos will often employ a system such as this. As a general rule, most airbrushes that are suction-fed will be fitted with a larger nozzle – 0.3mm or larger – as it is assumed the user will be

painting larger surface areas. However, if the user is only working on smaller, more manageable sizes, then a gravity-fed system is more suitable. Added to this, a gravity-fed system will use every last drop of paint, proving more economical with expensive, detail paints. A suction-fed system will often have unused paint in the bottom of the cup that the feed tube cannot reach. Cleaning out between colours too, can be easier with a gravity-fed system, as you don't have to flush out the paint feeder tube that a suction-fed system has. You will only have to clean out the bowl or paint reservoir of a gravity-fed system which, by its nature, is always going to be quicker, if you are using multiple colours but with only one airbrush.

Floating and screw-in nozzle systems

Different manufacturers prefer to configure the front of their airbrushes in different ways. Airbrushes that have a screw-in nozzle system have been designed for infrequent nozzle changes. The advantage of this system is that it is less likely that the air supply will work its way into the paint reservoir and thereby result in bubbles appearing in the paint cup.

Alternatively, the floating nozzle system offers a quick and easy way of interchanging needles and nozzles within one airbrush body. It also allows for easier maintenance, as there is easier access to the needle housing through the main body of the airbrush, allowing quicker and more thorough cleaning.

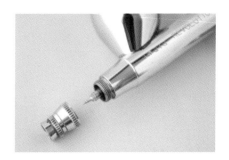

Screw-in nozzle type.

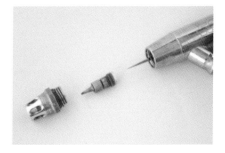

Floating nozzle configuration.

Now that you know all the different varieties of airbrush available, you can make a decision as to which one is best for you. If you really don't know, then consider what work you will be doing most frequently, what medium you will be using, and what surface you will be painting on. Some airbrushes are designed as a 'one size fits all'. These are usually fitted with a 0.3mm nozzle and give the user the option of suction- or gravity-fed paint cup systems. Obviously, the bigger the nozzle size, the greater the volume of paint will be emitted. You will also be able to put 'fancy' paints such as light flakes, metallic and pearls through a bigger nozzle size. Small nozzle sizes (0.2mm and smaller) simply will not cope with the particulate sizes within the paint, and are primarily designed for the finest of detail work.

Airbrush maintenance and first aid

Your airbrush is a precision instrument that has been manufactured to a high specification. There are, on average, twenty to thirty individual components that make up your airbrush, although several individual parts make up a whole component that the user would treat as one (the air valve assembly, for example). As the airbrush is a mechanical device with moving parts, it is not really surprising that sometimes things will go wrong: parts get damaged, wear out or may be accidentally lost. In this situation the airbrush will not behave as you want it to; you may find it difficult to control and unexpected things may happen. This chapter has been written to help you understand how your airbrush works, what each component does, what will happen if certain parts fail, and how to avoid causing damage to your airbrush when cleaning, dismantling and rebuilding.

At any stage in your learning, it is vital that you have a full understanding of your airbrush. Whether you are a complete novice, have had some experience or even quite a lot of (troublesome) experience, this chapter has been written to give you the confidence not only to dismantle your airbrush to clean it, but also to put it back together correctly, and, just as importantly, to be able to identify any problems you may encounter and cure them.

Do not be frightened of your airbrush: if you treat it with care and respect, together with a little knowhow, you should have years of pleasure and great satisfaction from it.

Taking your airbrush apart

Think of your airbrush as a small jigsaw puzzle. As the user, you really only need to worry about approximately a dozen or

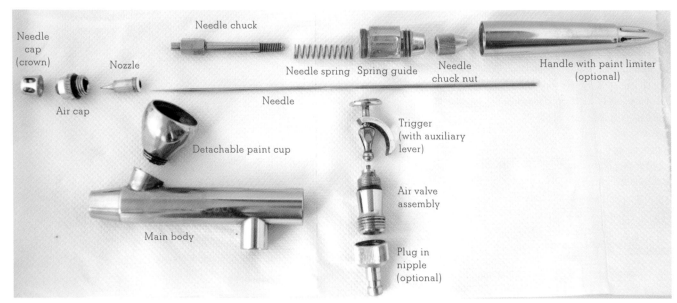

The disassembled airbrush with all the key parts shown.

so pieces on a regular basis. The pictures here show you what you should expect your airbrush to look like when dismantled. Depending on what sort of airbrush you have (as already discussed in the previous chapter), you should carefully lay all the pieces out onto some tissue on a flat surface as illustrated.

As a rule, it is best to dismantle and reassemble your airbrush in some sort of sequential order. You will in time become used to this and eventually be able to do it with ease. The recommended sequence is to start at the back and work your way forward to the front. Ensure you have all the correct tools to hand, such as airbrush cleaner, specific spanners, screwdrivers, nozzle/pipe cleaners, cotton buds (Q-tips), reamer (a flat-sided needle to clean inside nozzles) and tissue.

1. Remove the handle (rear part of the airbrush). The needle is held in place by a locking nut. The needle can be carefully removed by pulling backwards until it leaves the airbrush.

2. Check the needle for cleanliness and damage. If the needle appears undamaged to the naked eye, double check this by dragging the needle at an acute angle over some dry tissue, whilst twisting the needle. If the needle does not have any damage, it should easily slide over the dry tissue. However, if the needle has a microscopic 'hook' or bend at the end, it will snag the tissue. Needles with a minor bend in the end can be straightened in a similar way, but on a smooth, hard surface. By applying a little pressure at the middle of the needle, gently 'lever' the bend out, twisting slightly as you add pressure. If there is a hook at the very tip of the needle, you will need to replace it as

soon as possible. A hooked needle tip will often result in a grainy atomization of paint. Once satisfied with the state of your needle, carefully place flat on the tissue next to the airbrush handle.

3. Needle spring assembly. This part varies from airbrush to airbrush,

model to model. The examples show some variations of this. Once the needle locking nut has been completely removed, the remaining assembly should come apart into three or four pieces: spring, needle clamp, needle clamp body and sometimes an auxiliary lever (designed to make the trigger action

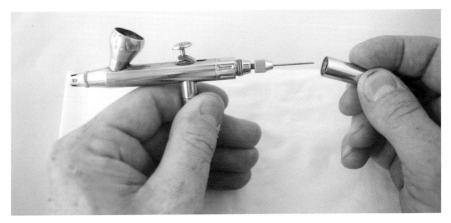

Remove the handle at the back.

Remove the needle by first loosening the needle chuck.

Check if a needle is damaged by dragging back while twisting it on some tissue.

smoother when pulling back). Check for cleanliness and place in sequence on the dry tissue next to the needle.

4. Trigger and air valve. The trigger itself sits on top of the air valve, but is held in place by the needle. Now that the needle has been removed, the trigger can now be easily pulled out. The trigger should be checked for cleanliness. Some models have an auxiliary lever attached to the trigger. The air valve part of the airbrush with most modern airbrushes is screwed into the bottom of the tool. To remove this, unscrew the whole assembly out of the main body. If this proves stubborn, try wrapping some tape around the component and loosen

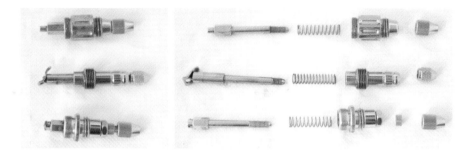

A variety of needle spring assemblies on different types of airbrush. Harder & Steenbeck Evolution (top); Iwata Revolution (centre); and Hansa 381 (bottom). Note that single-action airbrushes do not have an assembly like this. Only independent and fixed double-action airbrushes are designed with this type of assembly.

using pliers or a wrench. However, be careful as some models have the air valve assembly accessible only from underneath via a retaining screw that holds the whole inner workings of the air valve assembly within the main lower airbrush body. If this is the case, only disassemble if your trigger shows a sign of sluggishness when turning the air supply off.

5. Front assembly: again, this part varies with different airbrushes. However, it is usually made up of an air cap, nozzle and crown (needle cap).

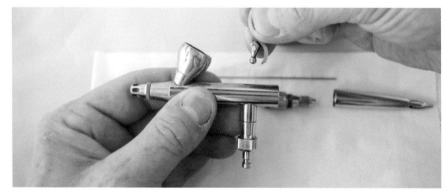

The trigger should pull out once the needle is removed.

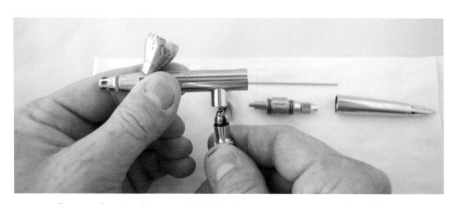

Remove the air valve assembly if it is just a screw-in type, as shown here.

- Floating nozzle system: as mentioned, this construction of airbrush offer the user an easier way of interchanging nozzle sizes, and to an extent, an easier way to clean thoroughly without complex stripping down of parts. Remove the nozzle from within the air cap. There is usually a seal (rubber or plastic PTFE) at the back of the nozzle. It is this seal that separates the air from the paint at the back of the front assembly inside the main body of the airbrush. If this seal is damaged or missing (it is easy to lose this down the sink when cleaning!) then air will take the route of least resistance and go back up to the paint storage area (cup or bottle).

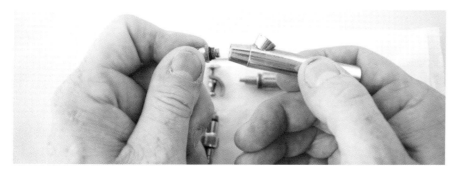

Remove the front assembly of the airbrush.

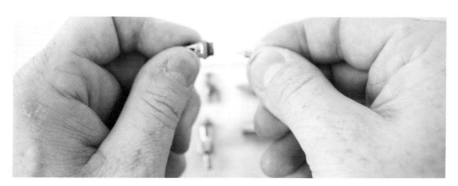

Floating nozzles can be simply pulled out of the aircap.

The nozzle seal sits at the back of most floating nozzles.

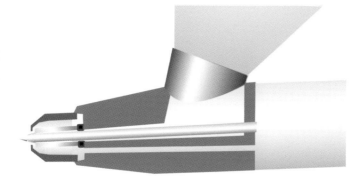

Ensure that you look after this component; a seal will fail if incorrectly fitted or is damaged, which will result in bubbles appearing in the paint cup.

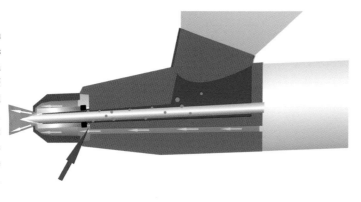

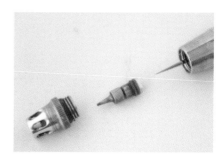

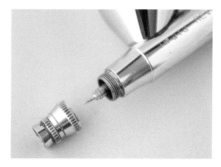

Pictures showing floating (above) and screw-in (below) nozzle arrangements. Note that the screw-in nozzle has flat spots for removing and tightening with a small spanner (often included with an airbrush when purchased).

- Screw-in nozzle system: often with these airbrushes, the nozzle is an exceptionally small part, often the smallest and frequently one of the most expensive to replace. Taking this part out and putting it back in needs to be done with the utmost care, especially when it comes to tightening up when putting back in. Because of the small, delicate nature of the part, it is all too easy to overdo the tightening and have the screw thread part of the nozzle shear off. Once out, however, the nozzle can be cleaned in much the same way as a floating nozzle.

6. Air cap and nozzle cap/crown: these parts of your airbrush house the nozzle (either type of internal mix airbrushes) and the opening determines how the air comes out of the airbrush. If this opening has any dried paint in it, the air flow will be compromised, leading to poor paint atomization as not enough or no air can come out of the front. The needle cap, or crown as it is sometimes called, serves no purpose other than to protect the needle from damage when the airbrush is put down. The airbrush itself will operate normally with or without, and it is standard practice amongst seasoned airbrushers to produce fine and detailed work with this part removed.

Lubricating your airbrush

As your airbrush is a mechanical tool with moving parts, it is therefore to be expected that it will operate better with some lubrication of certain parts. What lubrication you use is open for debate. Some suggest using a specific airbrush lubricant, often produced by the airbrush manufacturers themselves. However, the general consensus is to use whatever lubricant you have in the home/ studio, be it petroleum jelly, synthetic oil, vegetable or olive oil. Whatever you use, make sure you use it sparingly.

The main areas to lubricate are around the bottom of the trigger where it makes contact with the air valve, and the middle of the needle where it makes contact with the needle seal (or packing seal) deep inside the main body of the airbrush. Lubrication here will help avoid the needle 'gluing' itself to this seal when the airbrush is not being used for periods of time. It is also good practice to add a little lubrication to the needle spring and needle clamp to maintain a smooth trigger action. Whatever you are lubricating, use very small amounts and apply with a cotton bud or Q-tip, remembering to wipe off any excess.

Lubricating an airbrush in the correct places will ensure a smoother trigger action.

Airbrush first aid

This section of the book is intended to make you aware of what can go wrong with your airbrush, what has caused the problem and how to put it right yourself. One of the biggest misconceptions about airbrushing is that the airbrush is a high-maintenance, temperamental and complicated tool to use, requiring a great deal of skill and knowhow. This is simply not the case. As already mentioned, there are really only about fourteen parts of the airbrush you need to worry about. The guide below will help you identify and cure any problem you may, at some point, encounter with your airbrush. However, these problems are not necessarily the fault of the airbrush. It may be working perfectly, but instead it may be a 'handling fault' that is causing the issue. You, as the user, will learn in Chapter 4 (Getting Started), how to handle the tool correctly to avoid problems. A small section of the guide will help give you a snapshot idea of where you may be going wrong.

SYMPTOM/FAULT	CAUSE	CURE
Bubbles in paintcup/reservoir	Incorrectly fitted nozzle	Clean and refit nozzle
	Nozzle seal malfunction	Refit or replace nozzle seal
	Nozzle front aperture damaged	Replace damaged nozzle
Paint in main body of airbrush	Needle seal damaged or fitted incorrectly	Check needle seal and refit or replace
	No needle present	Fit needle
Intermittent/no paint being sprayed	No paint in paint reservoir	Add paint to cup/reservoir
	Too thick a paint added	Thin paint to correct consistency
	Blocked or unclean nozzle	Clean inside of nozzle
	Air pressure too low	Increase air pressure
	Air hole in lid/jar blocked causing vacuum	Unblock air hole in lid or jar to prevent vacuum.
Trigger sticks when pressed down	Dirty/unlubricated valve plunger in air valve mechanism	Clean and lightly lubricate top of valve plunger
	Paint build-up/dirt around trigger inside airbrush body	Clean trigger thoroughly
Trigger sticks when pulled back	Dirt/paint build-up around needle seal	Clean and lubricate around the needle seal and needle itself
	Dirt/obstruction around needle spring mechanism	Clean needle spring mechanism
	Bent needle	Roll needle for straightness and replace if necessary

SYMPTOM/FAULT	CAUSE	CURE
Constant paint flow from nozzle	Incorrectly fitted trigger or needle spring mechanism	Refit trigger and/or needle spring mechanism
	Incorrectly fitted needle	Ensure needle is fitted fully forward inside nozzle
	Worn out nozzle	Check nozzle tip is not 'fluted' in shape or damaged. Replace if damage evident.
	Debris inside nozzle	Remove dried debris with reamer
	Bent needle	Replace badly bent needle with new straight one.
	Damaged air valve assembly	Replace air valve parts or complete assembly
No air coming out of airbrush	No compressed air source	Ensure air source is switched on
	Damaged or obstructed hose	Check hose is unobstructed and undamaged
	Stuck or damaged air valve assembly	Check and lubricate air valve; repair or replace
	Blocked aircap aperture	Clean inside aperture
	Incorrectly fitted/damaged nozzle seal	Refit nozzle seal; repair or replace nozzle seal
Bubbling/leaking from nozzle	Nozzle assembly not tight enough in main body	Tighten with fingers or specific assembly wrench. DO NOT overtighten!
	Damaged nozzle assembly seals	Replace any damaged seals
	Liquid present in nozzle screw thread	Dry out screw threads with tissue before re-assembly
Uneven spatter or spitting medium, including coarse spray pattern	Paint too thick for nozzle size	Thin paint to correct consistency
	Air Pressure too low for paint type	Raise air pressure to suit medium being used
	Paint build-up on needle	Clean tip of needle carefully with paintbrush and cleaning fluid
	Damaged or 'hooked' needle	Replace damaged needle
	Damaged nozzle	Replace damaged nozzle
Uneven or broken line spraying	Partially blocked nozzle	Clean inside nozzle
	Medium still too thick for nozzle size being used	Thin paint further
	Air pressure still too low for paint type being used	Increase air pressure
	Paint build-up in nozzle cap aperture	Clean and refit aircap

Mechanical faults

Here we have some examples of what things can go wrong with your airbrush, together with some diagrams to help give you a better understanding of your airbrush. Listed below are a few of the most common faults and causes, together with some explanation as to how you can cure them yourself.

Sometimes it is not your airbrush that is at fault. It may be in perfect working order, as is the compressor, and you may be using an ideal medium. It may actually be you, the user, who is at fault. Listed here are some classic problems that occur through incorrect handling of the airbrush, and ways in which these errors can be easily remedied.

When things go wrong, it is important to not get flustered or frustrated with your airbrush. To do this will often prove fatal to your airbrush and expensive for you. Always remember, there are only so many things that can cause your airbrush to go wrong and only a limited number of parts that are giving you the trouble in the first place!

SYMPTOM/FAULT	CAUSE	CURE
Paint 'floods' on surface	Paint too diluted	Re-mix paint to correct viscosity
	Too much paint applied in a concentrated area	Use less volume of paint
	Poor control of airbrush where movement is not fast enough for paint volume and/or distance from surface	Better control over speed of airbrush movement, distance from surface and volume of paint used
Paint 'spiders' on surface	Airbrush too close to surface in relation to the amount of paint being used	Move further away from surface, or use less volume of paint
	Paint being released before air	Press down first, then pull back*
Paint 'blobs' at start of stroke	Usually a result of stationary start	Begin arm movement before paint application (a 'run up' start)
	Paint being released before the introduction of air	Press down first, then pull back*
Paint 'blobs' at end of stroke	A result of movement stopping before paint supply closed off	Shut off paint supply while arm movement continues on a little
Paint spits at beginning or end	Paint is introduced **before** air and then trigger allowed to snap off	Press down first, then pull back*; push forward then release to finish

*Relates to independent-action airbrushes

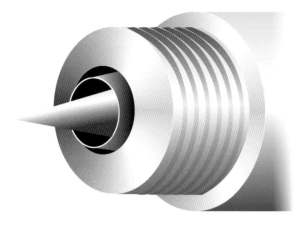

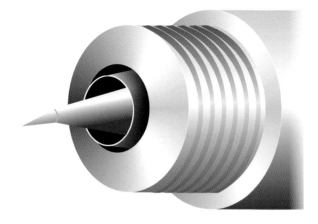

A nozzle in perfect order. The needle should be clean and straight, the nozzle free of debris and wear, and the aircap clear to allow a free flow of air.

A needle with a kink in it will merely change the direction of your spray. This can be remedied by 'rolling' the needle with a little pressure on a hard surface.

Cleaning your airbrush

CLEANING THE NOZZLE

Regardless of whether you have a floating nozzle or screw-in variety, it is important to prevent a build-up of debris such as lumpy, poorly diluted or 'dirty' paint (where dried flakes of paint from the edge of the paint container fall into the airbrush paint reservoir). Putting a poor fuel into a car will eventually lead to an expensive garage bill; an airbrush is no different, so always be vigilant as to what you put into your airbrush in the first place. Assuming that you have successfully taken your nozzle out of your airbrush, you can carefully clean the outside of the nozzle with a paint brush and relevant cleaner, where occasionally dirt, debris and paint can build up if the aircap has not been fully tightened (or the nozzle not screwed in correctly, for screw-in nozzles) while there is still paint present in the cup. However, it is nearly always the inner part of the nozzle that requires the most detailed and thorough cleaning – the 'business end' of the airbrush – as this is where the paint goes immediately prior to leaving the airbrush. The very front tip of the nozzle is also of vital importance as the condition of this is influential in the quality of spray being emitted from the nozzle. Any wear, mis-shaping or blockage will nearly always lead to frustration and a poor quality outcome. To clean a nozzle, firstly use a corner of tissue twisted into a compacted paper 'needle'. Push this into the back of the nozzle and twist, further compacting the tissue. This will gently clean the inside of the nozzle. However, dry, stubborn paint may need a little more encouragement; if this is the case then you should employ a reamer: a needle with a shaped, flat angled side that will scrape away harder debris from the inside of your nozzle.

Never use anything abrasive such as wet or dry sandpaper or scourers on your nozzle, as these are far too aggressive to use on such a delicate component.

CLEANING THE AIRCAP

This part is much easier to clean than a nozzle, as it is generally a far more robust component. Usually, only a paintbrush, tissue and reamer are needed. The primary objective is to ensure that the inner aperture of the main air hole is kept clean and clear, by using a reamer and gently scraping away any build-up of paint. If paint is allowed to build up on this component, the airflow from the tip of the airbrush will eventually become restricted.

CLEANING THE NEEDLE

When cleaning a needle, soak some tissue in appropriate cleaner, pinch tissue around needle shaft and pull all the way back through. Repeat until clean. Usually paint can build up at the point on a needle where the needle seal in the airbrush body makes contact with it. This will sometimes look like a thin, dried-on 'collar', halfway down the shaft of the needle itself. As already mentioned, use tissue and a cleaner and pinch the tissue around the needle, pulling it back until this paint build-up has been removed.

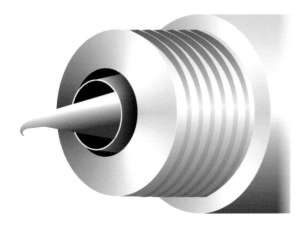

A needle with a bent tip is virtually impossible to fix. This damage is often too bad to repair. Paint cannot atomize correctly and will prove difficult to control; excessive 'spitting' will be in evidence. The only remedy is to replace the needle.

A damaged or split nozzle will also prove impossible to control. Forcing a needle too far from the back of the airbrush when replacing it will cause wear through fatigue to the nozzle. Dropping a nozzle when cleaning will not do it any good either. A damaged nozzle must be replaced immediately.

A blocked aircap will cause your spray pattern to become uneven. You may also experience an unexpected drop in air pressure and the paint will not atomize correctly. Simply remove the aircap and clean with a reamer and cleaning fluid.

A blocked nozzle is generally the result of incorrectly mixed paint or paint being allowed to dry inside the nozzle. Thin your paint to the correct viscosity and flush your airbrush through with water and/or cleaning solution when finished.

GENERAL CLEANING

Ideally, you would only want to strip your airbrush down at the end of the day or at the end of a job. It should not be necessary to strip down several times during the day when using an airbrush. Ideally, flushing water, cleaning fluid and water again between colours is sufficient. After a prolonged spell where the airbrush has not been in use, you may want to consider taking only the needle out and running a little cleaning solution through the airbrush to help an initial lubrication of the tool before any major work commences.

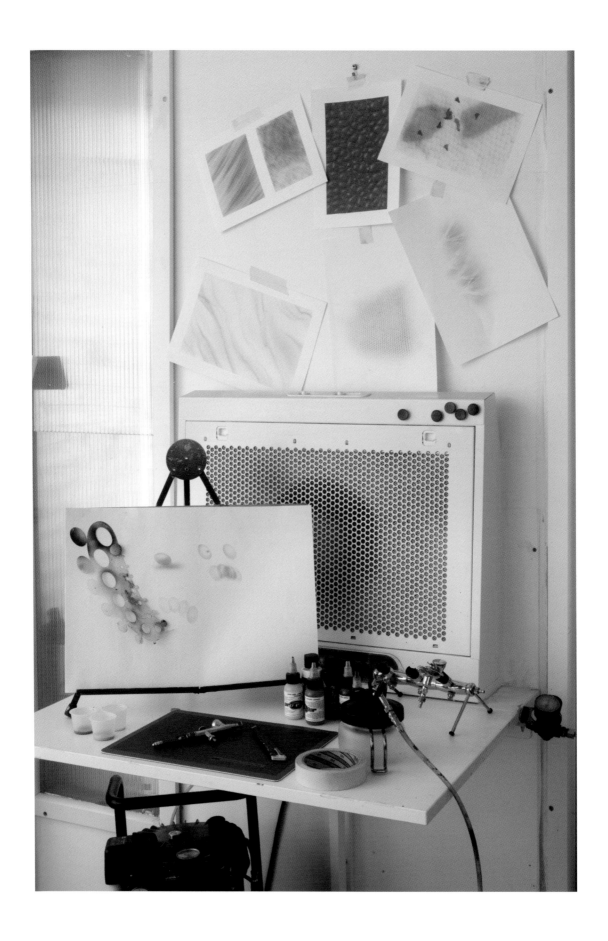

Chapter 3
Materials and equipment

The equipment you need to use will vary according to your airbrushing requirements. This chapter covers three areas: the absolute essentials; additional equipment that is useful for any beginner; and further equipment that some may consider an unnecessary luxury, but others may consider to be just as useful.

Essential equipment

Air sources

Assuming that you already have an airbrush and a hose (see previous chapter), you will now need to power it with some form of compressed air. Deciding on what form of air source you use ultimately depends on how often you intend to do airbrushing. It is recommended that you have some form of filter (ideally with a regulator) fitted to one end of your hose, regardless of the type of air source.

A regulator/filter is vital to ensure clean, dry air is pushed into your airbrush, free of oil and moisture. The regulator will also enable the user to choose a precise air pressure to work at, depending on the type of work being undertaken.

For the very occasional user, a can of compressed air is an inexpensive choice. However, frequent use of your airbrush will make this a costly method. A 300ml can of air will give on average one hour's (continuous) use. If this method is used, it is a good idea to place the can

in a bowl of tepid water (about 5cm deep). This stops the can from super cooling as air is used. Without the bowl of water, compressed cans of air tend to freeze as the can reaches the end; by placing it in water, all the air can be

used in the can without cold, wet air working its way into the airline.

Compressed air bottle canisters offer a longer life, but there can be an initial hire cost of the bottle that may put some off. This is a useful system to consider if

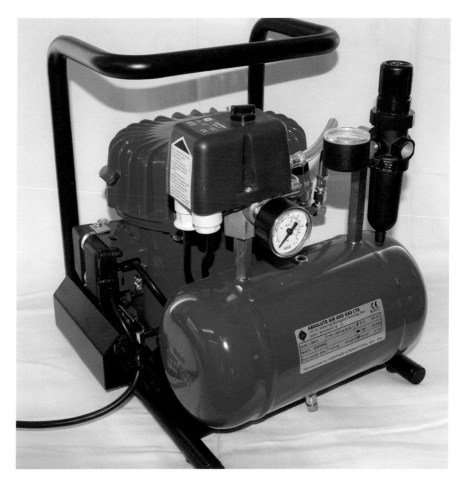

A high quality, small, silent compressor with a maximum working pressure in excess of 50psi will allow you to achieve most airbrush work.

LEFT: A small studio set-up, consisting of extractor, desktop, easel, good quality lighting (daylight simulation) and an accessible air regulator.

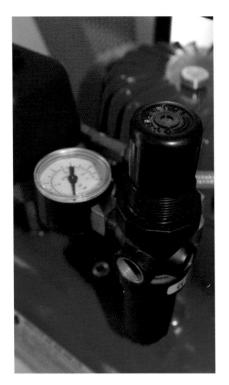

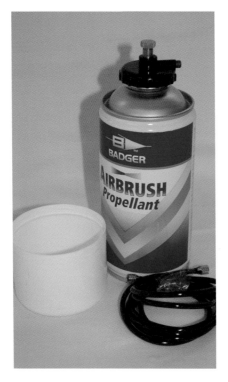

time immediately afterwards to cool down (a 50/50 duty cycle). If you airbrush frequently for longer periods than this, you will need to have a compressor that either has a larger air reservoir (or tank) and/or a better duty cycle such as 60/40 or 70/30.

Paints

The type of medium you use through your airbrush will depend entirely on the type of work you are doing, what you are painting onto, and the conditions under which the work will be kept. Whatever you use, the crucial consideration will be the viscosity of the medium you are using. This in itself will be covered in the next chapter in much greater detail. However, for this section it should be noted that the correct paint should be used for the application for which it is

A filter regulator is essential to ensure your air is clean and set correctly.

Disposable cans of compressed air are ideal for occasional, light use.

you ever intend working out 'in the field' where an electric power source may not be an option for a compressor. A bottle of compressed air (usually CO2) will last several hours (perhaps two or three solid working days) running a single airbrush. The air that comes from one of these bottles is clean and dry. Because of this, you do not need a moisture or an oil trap. A regulator is essential to control the air pressure, however, as these bottles can operate at a dangerously high pressure if not checked.

Compressors come in various forms, sizes and shapes. The cost also varies enormously too, depending ultimately on what they are designed for. Regardless of what sort of compressor you finally go for, always remember that although your airbrush collection may change and develop, your air source will remain constant. Without a reliable

source of air, your airbrush will never operate properly. If you can afford to, buy bigger or better than you initially intend, taking into account what you may expect from it in the future.

When choosing a compressor, firstly consider the type of work you will be doing and the frequency with which you will be airbrushing. Work out how long your airbrush will be in your hand compared to 'rest' times when you may be doing other things such as cutting masks. This is important, as virtually all compressors work on what is called a duty cycle. This can be measured by the time the compressor is actually running compared to the time it needs to stop and cool down. Some of the very cheapest compressors will run at a low maximum working pressure (about 15–20psi) and will only run for five to ten minutes before needing an equally long

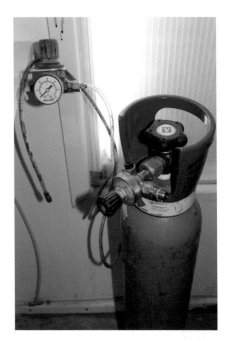

Bottled gas canisters will last longer and are useful to have if you are working 'out in the field' where no power source is available.

intended. Any type of paint, dye, ink or colourant will go through an airbrush regardless of whether it is water-, solvent-, spirit- or oil-based. For tips on mixing paints to the correct consistency, see Chapter 4.

Acrylic paints

These water-based paints have improved vastly over the last twenty years with dozens of different manufacturers all producing exceptionally fine pigmented paints. These waterproof paints are designed to go through the smallest nozzles, and give a rich, even colour that dries quickly and does not yellow with age. Even household emulsion, if thinned to the correct consistency, will go through an airbrush, as this is another form of water-based acrylic paint.

Fine artists' acrylic paints are manufactured for ease of use with an airbrush. Usually they are already thinned to the correct consistency (and as such, are referred to as liquid acrylic inks). However, for extreme detail and subtle tints they can be thinned further with water. Other acrylic paint will often need thinning and will either need a reducer (a water substitute that thins paint and often speeds up the drying time) or water. A major advantage of modern airbrush acrylics is that manufacturers will produce colours in both opaque (solid colour) and transparent colours. This gives the user the flexibility to use either or both paints in a composition to gain vivid colours or the most subtle of faded tints.

Today, most colours applied to vehicles in production are water-based acrylic paint that is then lacquered over for protection from the elements. These automotive paints can also be used through an airbrush, but usually with a slightly larger nozzle (0.5mm). Although identical in type to artists' acrylic, automotive acrylic paints are designed primarily to be sprayed on large surface areas and not to create fine detail, like the artists' variety of acrylic paint. Having said this, it is possible to use one directly on top of the other, or even to mix the two together to create a 'mongrel' acrylic, which can then be thinned to create solid blocks of colour or backgrounds.

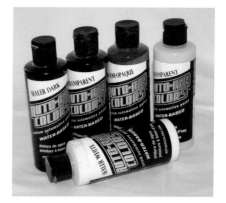

Water-based automotive acrylics are designed to cover larger surface areas and are lacquered over for protection from the elements.

Watercolour paints

Watercolours were the first medium used with the advent of the airbrush, as they offered transparent, tinted subtleties over photographs. By the same token, watercolours also offer luminosity and brilliance when painted over a white ground (surface). Watercolour generally comes in paste or block form, but can also be purchased in a liquid form, ideal for airbrushing.

Concentrated liquid watercolours.

Gouache

This paint type is very similar to watercolour, except that it usually comes in paste form. Another difference is that it is an opaque paint, but it can be used delicately as a transparent tint over already laid opaque colours.

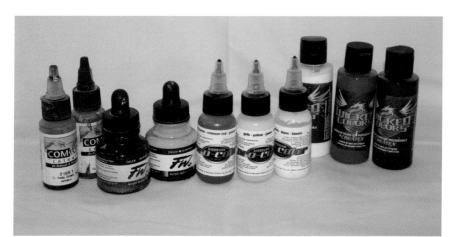

A selection of water-based liquid acrylic paints. Some are ready mixed; others will need to be thinned to the correct consistency.

Inks

Inks are ideal to put through an airbrush; indeed, they are the ideal consistency that all other paints going through an airbrush should be measured against. Inks are widely used as they offer rich and vibrant colours when used on a white ground. A useful tip when using inks, however, is to wear some form of glove, preferably cotton, as inks are particularly prone to reacting with the natural oils on the skin.

Food colourings

Just like watercolours, food colourings are available in a variety of liquid/paste states. The more concentrated colours can be thinned in the same way as gouache, but modern airbrush food colours are ready mixed to the correct consistency. Because of the watery nature of this 'paint' – as you would expect with a dye – it is standard to use a lower air pressure when using these. Ideally, many thin layers should be applied to create the desired intensity of colour. Too much too quickly will risk ruining the icing, which may prove difficult to repair.

Edible food dyes are also available in liquid or paste form.

Textile paints

Generally, textile paints are a derivative of acrylic paint, but with the addition of ingredients which make the colours more washproof and resistant to detergents. However, artists' acrylic can be converted into a textile paint by using an additive in the colour, often called a textile medium or additive. Textile paints are often fairly thick and need a higher pressure to get the paint successfully through the nozzle and into (rather than onto) the fabric itself.

Body paints

Body and make up 'paints' have improved hugely in the last decade and have become very popular in mainland Europe, and also for the TV and film industries. Body paint can be thinned from a paste to a useable liquid and is usually applied at a slightly lower pressure for safety reasons.

Enamels and polyester-based paints

These have been put in the same category as they should be treated the same. However, it is not recommended they be mixed together, as one is spirit-based (enamel) and the other is solvent-based (polyester). The latter is probably better known as solvent-based automotive paint. Respiratory equipment and effective air extraction are strongly recommended when using either of these paints. A greater degree of care needs to be applied too: a larger slice of patience (especially with the enamel) will be needed due to the presence of solvents/spirits, which will adversely effect the drying time of the paints. Further to that, some masks or templates may react to the solvents if too much is applied too quickly, spoiling results.

Additional equipment

Stencils

There are probably thousands of different stencils available for the airbrush market, each with its own specific use. To begin with, perhaps choose a couple that are of interest to you and that will aid your work. However, the trick with any stencil is not to rely too heavily on it. Stencils should really only ever be used as a starting point, and then adapted to suit the work you are doing. Ideally, they should always be combined with a lesser or greater degree of 'freehand' work, where you are not using any stencils at all. That said, it is always useful to have some generic type of stencils to hand, such as curves, circles and ellipses. You will find these very useful to create natural hard-edged curves, with speed and accuracy.

Positive and negative stencils or templates form the inside or outside of a shield, either to protect an already painted area or to create an area ready to paint.

Drawing and painting aids

These are essential for the fine artist or illustrator, as well as having numerous other applications. Being an airbrush artist does not necessarily mean you should also be a slave to the tool. There is nothing wrong with combining your airbrush with other aids such as paintbrushes, pens, pencils, pastels, sponges and so on. And in producing initial design work, it is useful to have a selection of the tools and materials listed.

Erasing equipment will allow you to remove paint, whether to eliminate mistakes or add fine detail.

Cutting equipment

This should be regarded as another essential for most work, with the exception of those who choose to work entirely freehand. Having a steel ruler, craft knife and cutting mat are all that is required for a basic kit. What type of craft knife you use depends very much on what works best for you, whether it is the scalpel type or retractable snap-off variety.

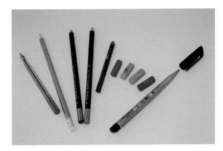

All artists should have a selection of other painting and drawing items that they feel comfortable using.

Painting by 'subtraction'

This useful technique has a wide range of applications. As the title suggests, paint or pigment is deliberately removed from the surface to create texture and fine details that are different in quality to what the airbrush produces. It is also a useful technique to employ in rectifying small mistakes. The tools used to employ this technique are inexpensive and easy to use. An eraser pencil can be employed to rub fine layers of paint back to reveal previously laid colour. As a rule, use the white (hard) type for porous surfaces such as paper and board, and the pink (soft) type for non-porous surfaces such as metal and plastic. A knife can also be employed in the same way to scratch away paint – to create individual strands of hair, for example.

Masking materials

As an alternative to using manufactured stencils, it is common practice to use other materials to make your own customized, specific materials. Materials such as paper, tracing paper, acetate (overhead projector film or plastic binding covers) can be drawn on or just printed with a chosen image. Cutting these materials with a knife will give you a crisp, clean edge if sprayed correctly.

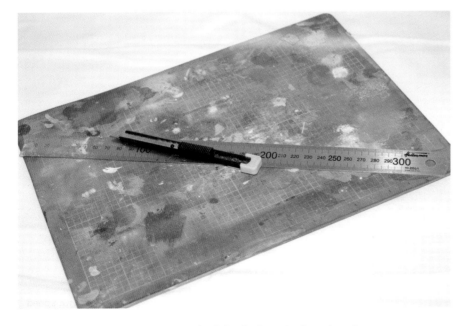

Basic cutting equipment: knife/scalpel, steel rule and cutting mat.

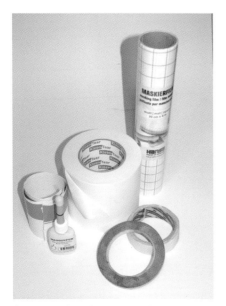

A variety of masking materials will enable you to work more efficiently.

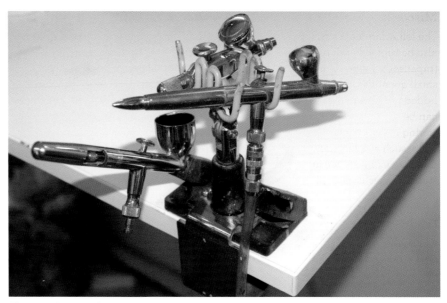

Keep a selection of cleaning tools and equipment close to hand for ongoing cleaning and maintenance as you work.

All these types of masking are referred to as 'loose masking' as the material itself is not fixed to the surface and can be removed and replaced quickly and easily.

Hard or fixed masking, however, can be a little more involved in its use, but can give the crispest possible edge you can achieve. This is ideal for technical work and for making an image stand out from a background. The three main types of hard masking are masking/application tapes, frisket films, and liquid latex. All these types of masking are physically attached to the surface. In the case of liquid latex, it should be applied with a silicone 'brush' tip, as once dried it will ruin paint brushes.

Cleaning equipment

Being able to clean and maintain your airbrush as you go along is essential for trouble free airbrushing. Some basic equipment should include toilet tissue, small pipe cleaners or interdental brushes, which are a good alternative available from chemists and supermarkets. Cotton buds (Q-tips) are also useful, as well as some form of reamer. Cleaning fluid appropriate to the type of work you do should also be kept as part of your basic essential kit.

An airbrush holder or cleaning pot is also essential as it gives you somewhere safe to keep your airbrush when not in your hand. It also allows you to remove unwanted liquids quickly, cleanly and safely without unnecessarily filling your environment with spray.

An airbrush cleaning station is excellent, not only for holding your airbrush safely, but also to store and remove unwanted paint and cleaning fluid from the immediate atmosphere when flushing out your airbrush.

Miscellaneous items

The following inexpensive items should also be kept to hand: paint droppers (pipettes); palettes for mixing/storing small quantities of paint; jars and/or lidded plastic cups (soufflé cups), which can be useful for mixing colours and storing them for later use; some form of cloth, such as a tack cloth, to remove dusty overspray as you are working on surfaces such as card, plastic or metal.

Health and safety equipment

As you will be working in an environment where paint is sprayed to create an atomized mist, it is also essential that you have a degree of protection from anything harmful that could be inhaled.

It is recommended, therefore, that you have some form of face mask; these range from the simplest types, which are

Other useful items.

A face mask is essential for your own safety, especially if you do not have any form of extraction.

inexpensive, to the full-face filtered respirators suited to larger-scale work. For your own 'studio' environment, some form of extractor is also recommended. These can be purchased ready made: desktop varieties simply draw air and particulates away from you through a filter. Alternatively, you can create your own by using a domestic cooker hood extractor.

For work on a more industrial scale, you will need to invest in a system that draws air out from either ground level or through the floor. Don't forget that to make this system more effective, you will need to 'pull' air into the room to avoid creating a vacuum within the room. Professional spray-bake booths can be exceptionally costly, and should only be considered if you intend working on a professional basis with plenty of work to pay for it.

Further equipment

The following items are regarded by some as luxury items, but by others as essential.

Specialist stencils: a wide range of these is available.
Digital stencil cutter: computer-cut stencils with micro-precision accuracy.
Hand stencil cutter: a cheaper way of cutting materials quickly and with relative accuracy.
Electric eraser: useful for removing fine areas of paint quickly.
Lighting: daylight simulation bulbs or tubes, ideal for working in a correctly lit room when daylight is not always reliable.
Storage space for equipment and work: some form of container must be purchased for equipment such as airbrushes and paints. Some paints are best kept out of direct sunlight, as

are most masking materials (masking fluid goes off quickly in heat and light, and the adhesive glue on the back of masking films begins to melt and become unstable). A toolbox for airbrushes and paints is ideal for storage and moving equipment around. For paper, card and canvas grounds, some form of art storage container is needed (large drawers will suffice) or an area where they can be kept flat and dry. A large portfolio of a suitable size is often a good starting point. Any work you do should be valued and looked after; although the cost may be prohibitive, try to have your best work framed, mounted or displayed correctly. Remember, if no-one ever sees your work, no-one will ever want to buy it!

Setting up your airbrush studio

The main thing to consider is how much space you want to dedicate to your new-found passion. Answering this question will often be the deciding factor in how you set up your studio space. Personal circumstances will also be a major contributing factor. To begin with, let us assume that you, the reader, are not fortunate enough to have free access to about 150–200 square feet of space (single-car garage space) ready to dedicate to your new airbrush studio. Perhaps you have a small corner of a spare room or just the occasional use of the kitchen dining table. If this is the case, then you should consider your set-up to include alongside your airbrush and air source the following:

Extractor: either purchase a specific airbrush extractor or adapt your own from a cooker extractor hood. These can be used as a temporary table-top item, ensuring that you work in a safe, dust-free environment. Make sure your extractor is fitted with a filter, or all it will succeed in doing is moving progressively dustier air around your room. Having an extractor pull horizontally is more effective than pulling vertically. Try to set yourself up so your extractor is directly behind your work (as you look at it).

Easel: this depends on whether you are more comfortable working flat or upright. Either way, you should also find a steel sheet with some magnets – a useful item to help hold down work when you have run out of hands!

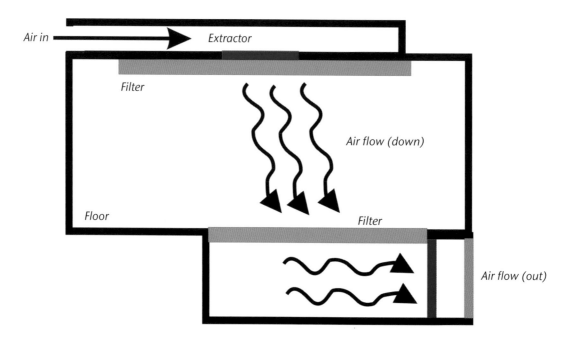

How a downdraft extraction system works.

Lighting: have some form of directional lighting, preferably daylight simulation lighting, guaranteeing you consistent light throughout the day, regardless of time or season.

Water: access to running water and a sink is advantageous, but not essential, as an airbrush cleaning station can be used as a substitute.

Furniture: a reasonably sized table surface suitable for the work you are undertaking and a comfortable chair are also vital. Standing and airbrushing can be quite tiring on the arms and legs for prolonged periods of time.

If however, you are lucky enough to have a large, dedicated space, you may wish to consider fitting into the wall on a permanent basis an air extraction system similar to the one already mentioned. This is ideal if you intend using primarily water-based paints on relatively small scale work, such as up to A2 sheets and canvas. As already mentioned, you may consider future-proofing your air source by purchasing a bigger, more powerful compressor. In a larger studio space, you would want to maximize your working potential by doing this. If you do have a bigger compressor, you may want to consider upgrading your air extraction system at the same time. Axial fans are excellent at moving air, but the fact is sometimes overlooked that to move air out

effectively, you need to replace that 'used' air with more fresh air pumped in. Failure to consider this will leave you working in a foggy vacuum! So remember to pump air in as well as out. If you want to combine this with the facility to use solvent-based paints, it is well worth adding a filtration system to this. You can have plain gauze filters or the more expensive but highly effective carbon filters, which remove a high percentage of noxious smells that may upset local residents (you will want to avoid a run-in with your local environmental health officer at all costs). Whatever system you have, it is essential that your compressor is fitted with an effective filter regulator that is easy to access quickly – ideally within arm's reach.

Chapter 4
Getting started

Let us assume that you now have your airbrush connected to an air source and a blank piece of paper in front of you. You are ready and raring to go. This is generally the 'make or break' stage if you have never done this before, where many who simply haven't researched how to airbrush now go wrong, with disastrous consequences.

The three key areas to be aware of are as follows: setting the correct air pressure; selecting the correct nozzle size for the chosen medium; and checking that the medium itself is at the correct viscosity. Too often, people will dive in using either too high or low an air pressure, and a paint that is much too thin or thick for the nozzle.

The table right outlines the pressure and nozzle size to be used with different types of paint. It provides a rough guide, or starting point, and is designed to give a degree of flexibility, as individuals will develop their own specific preferences.

Once you have a better understanding of how the concept of air pressures, nozzle sizes and paint types work, you need to gain a further understanding of what constitutes the right consistency for paint. Often manuals and instructions will describe paint as being the consistency of semi-skimmed milk. However, this rather vague description can be made a little easier to understand by using the guide sheet overleaf. The paint viscosity guide chart should be photocopied onto standard, plain white paper. Mix paint to 'approximately' the right consistency by

Air pressure/psi	Nozzle size (mm)	Paint/medium type
20–35	0.1–0.3	Liquid water colour Food colouring Over thinned paint Drawing inks
20–35	0.3–0.6	Gouache Body paint
35–45	0.3–0.6	Artists airbrush acrylic ink
45–55	0.3–0.6	Automotive acrylic Enamel/spirit paints Polyester/solvent paints
45–65	0.3–0.6	Textile based medium

Chart showing the relationship between air pressures, nozzle sizes and paint types.

eye, then test it by using this guide sheet. There will always be a degree of variation in the paint viscosity you mix that may be a result of the colour, brand and even air temperature. These variables should only be minor and not interfere with your ability to airbrush without any problem. Simply place three drops of your mixture onto the paper, into the circle at the top. Your paper should be on a flat surface when you do this. Then carefully pick up the paper and hold vertically, so the three paint drops flow down to the bottom. What you are looking for is the speed at which the paint flows down the paper. As an average, it should take approx thirty seconds for ready mixed acrylic paint to

flow from top to the 'finish' line. Thinner paints such as inks, food colouring and over-thinned paints will do the same in about twenty seconds. Conversely, thicker or stickier paints such as automotive acrylic, enamel, polyester and fabric paints by their nature will take a little longer to travel the distance – about thirty to forty seconds. As a general rule (which can be very easily broken!), if the paint does not reach the bottom finish line in the allotted time, it is too thick for your airbrush, and will need further thinning.

You can, however, try increasing the air pressure to compensate for the thickness of the paint you are using. The scale at the bottom of the chart will

LEFT: Hold your airbrush loosely in your hand. Avoid gripping too tightly with your thumb.

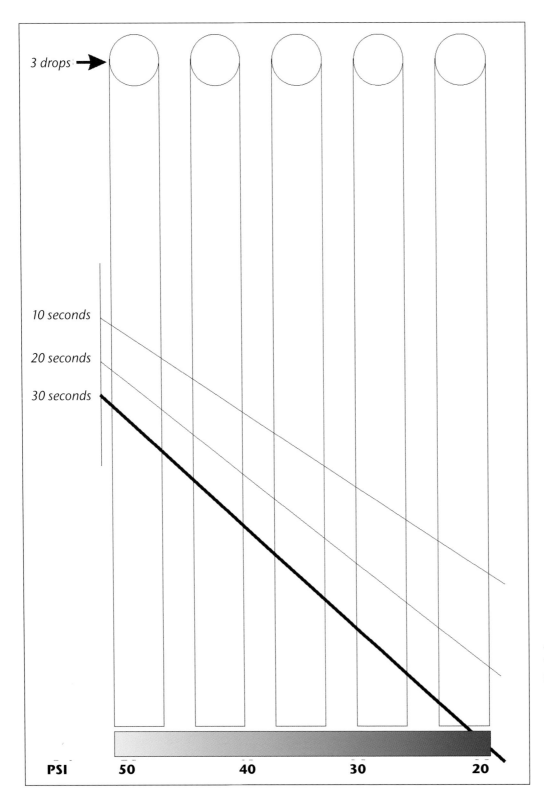

3 drops

10 seconds

20 seconds

30 seconds

PSI 50 40 30 20

A guide to correct paint viscosity compared to air pressure.

TESTING PAINT CONSISTENCY

If you are not sure that the consistency of your paint is correct, avoid filling up your paint reservoir unnecessarily. Instead, where possible, just use a few drops and do a quick test; it is better to be safe than sorry.

guide you as to what pressure you may want to change to, to match your paint mixture. As already stressed, this is merely a guide to get you started and give you a better understanding of what is required when putting paint into your airbrush.

So now you are poised ready with your airbrush. No doubt you are feeling a little tense and are beginning to hold your breath a bit by now. Really, you should be doing neither of these things, but as a beginner it's only natural to do this. Ideally, breathe deeply and slowly (helps aid a steady hand) and loosen your grip on your airbrush a little.

Holding your airbrush

Regardless of whether you are left- or right-handed, you should hold your airbrush like a pen. The bottom of the main body of your airbrush should rest on the side of your middle finger, and your index finger should sit comfortably on the front edge of the top of the trigger. The most common mistake is with the thumb. Some people grasp their airbrush tight with the thumb as if their lives depend on it. Holding your airbrush like this will only further your stress levels and ultimately result in thumb cramp. Loosen your thumb: it should serve no other purpose than to stop the airbrush from falling out of your

hand. Your thumb should barely touch your airbrush and the muscle at the base of the thumb should remain soft.

The question of what to do with your other hand is entirely up to you, as you can develop an airbrushing stance that is comfortable. As a guide, your choices are thus:

1. The 'shooting from the hip' stance – the one-handed airbrush method. If you are confident and co-ordinated enough to employ this method, go

'Shooting from the hip' stance.

The 'freeze' stance.

for it; you then have a free hand to do other things such as holding templates, pouring paint, stirring the tea, etc.

The wrist support stance.

Wrap your hose once around your wrist to stop it getting in the way.

2. The 'freeze' hand support: holding the airbrush in one hand, cup the other hand underneath to give extra support. You may find yourself doing this from time to time when your airbrush hand starts to get tired. Ideally, also place your elbows into your lower ribs; this will help your control with detailed work.

3. The wrist support: almost the same as above, except you hold the wrist of your airbrush hand with the other. This is merely a variation on a theme, which some people find just as comfortable.

4. My hose is getting in the way! To most people this isn't a problem and the hose is allowed to fall down naturally. However, should this prove annoying, try wrapping the hose once around your airbrush arm so it falls away at the elbow instead of the wrist.

Ready, steady ... GO!

Now you are ready to start spraying. To begin with, learn how to control the paint flow by altering your spraying speed and your distance from the paper. The four key elements to remember when airbrushing are speed, distance, paint and air.

General airbrush spraying

If you keep a constant flow of air and paint emitting from your airbrush onto a scrap piece of 'practice' paper, you will understand how the concept works. Assuming that your air pressure is set and that you have a small but reasonable amount of paint flowing out of your airbrush, you will soon discover how to control the paint flow with simple adjustments of speed and distance.

TIP

BALANCING THE FOUR ELEMENTS

Speed: the speed at which you work – whether left, right, diagonally, up, down, curved or any direction. The slower you work, the more concentrated the paint on the surface will be.

Distance: the distance your airbrush is from the surface you are spraying. The further away you are from the surface, the more diffuse the paint will be. Much closer work is reserved for fine detail and line work.

Paint: the quantity of paint you use is determined by the position of the needle in the nozzle. The further retracted the needle, the more paint volume is allowed to flow from the nozzle.

Air: the air pressure used to atomize the paint leaving the airbrush, usually somewhere between 15psi and 65psi as a workable minimum and maximum, depending on paint type and nozzle size being used.

Next are some exercises that you can recreate on plain paper as a warm up. Regardless of how experienced you are, always perform some form of practising before going headlong into a piece of work. A professional golfer will always take a couple of practice swings before addressing a ball; an airbrush artist should be no different and make a habit of practising their 'swing' before attempting a piece of work.

Detailed airbrushing

In time, you will learn that to create fine detail, you will need only a very small amount of paint. To achieve this, adjust your airbrush or 'set' it so that you have

a very fine line of paint emitting from it when about 1cm away from the surface. To gain control over very fine detail, try signing your name over and over again, progressively getting smaller and smaller. The closer you get to the surface, the more you will have to compensate by using less paint volume.

You can practise different qualities of fine line airbrushing by repeating all the exercises you have done in the general airbrush spraying section, only this time you will be addressing your surface from a much closer distance – somewhere between 2mm and 2cm.

When it comes to painting a line with a beginning and end, you have another element to consider. Try painting the line such as the one below from a distance of about 1cm away.

Target practice

This exercise is a test of your hand–eye co-ordination. It is also a good way to find out just how straight your needle is too! Assuming you have a good, new, straight needle this exercise will find out how accurate you are at aiming at a specific target at close range or from a distance. In this exercise your hand will remain static. You aim at a target and spray. Don't forget, however, that the further away you are, the more diffused and lighter your spray pattern will be. You can counter the strength of colour by spraying for a longer period of time the further away you are.

Graded tones

To create an effective graded tone, you have to develop a discipline where you gradually build up colour. There are, however, numerous techniques, each of which works for different individuals and is effective in its own way. This exercise will attempt to demonstrate two different ways of doing the same thing.

Airbrush	Paint/Medium	Surface	Tools/Materials
H&S Grafo T1	Liquid acrylic ink	Plain paper	Knife
Fixed double action			Plain paper
0.15mm nozzle size			Pencil
30 PSI pressure			

TECHNICAL DATA

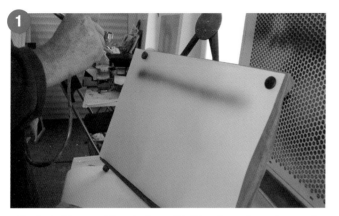

Firstly, hold your airbrush about 10–15cm from the surface and slowly (from one side of a piece of A4 paper to the other in about ten seconds), create a subtle, even fill of colour. It should be relatively transparent, even and diffuse.

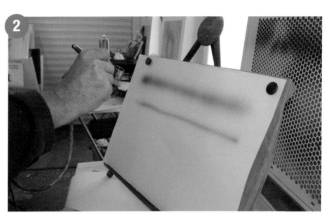

Now try the same again from half that distance. The line should still be quite diffuse, but more concentrated. You should maintain the same speed as the first attempt you did.

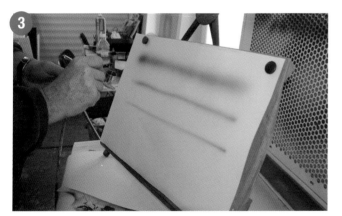

Repeat this, but double your speed. What you should achieve is the same width as your second line, but the concentration of colour you achieved in the first line.

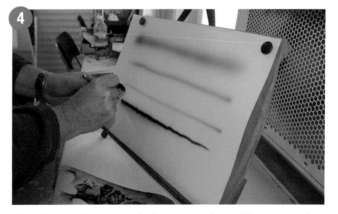

Now find the limitations of what you are doing. Maintaining the same amount of paint you have been using for this warm up, move to within 2cm of the surface. Repeat the slow movement from side to side of your paper as you did in the first line. The likelihood is that you possibly ended up with paint that 'flooded' and perhaps spidered over the page as you passed from one side to the other. Well done! You have just discovered the limit! (Do not be afraid of making mistakes like this as you will learn a lot from them.) Repeat this again, but this time, double your speed while maintaining a distance of 2cm from the surface.
On this pass, you will find your increased speed has countered the flooding/spider effect.

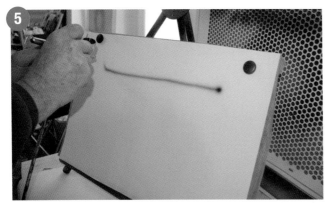

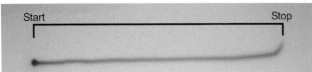

Start ⌐———————————————————⌐ **Stop**

A common mistake people make is to forget that they are starting from a stationary position. The ability to counter the 'splat' at one end and the 'splat' or 'lick' at the other lies in the movement of your arm.

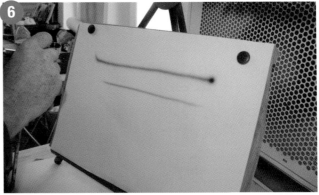

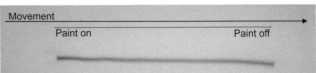

Movement ————————————————————→
Paint on **Paint off**

To paint a thin, straight line successfully, you should give yourself a 'run-up' of about 5cm or more, so that when you do start painting, you are already moving and the immediate build-up of paint will be eliminated. You should also do the same at the other end of the line, continuing your movement without any paint being emitted from your airbrush. Practise this technique a few times on a plain piece of paper until you have mastered it.

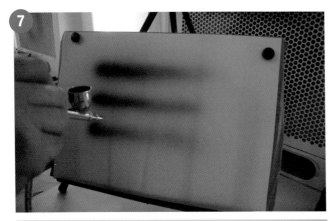

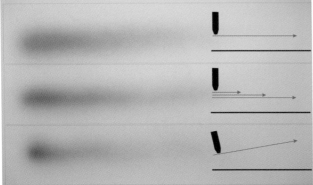

Graded tones.

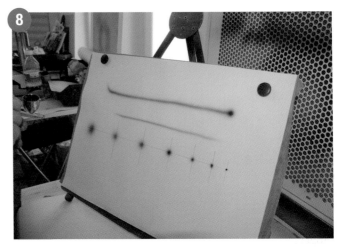

Target practice.

**PRACTICE MAKES
PERFECT**

Keep practising the simple things over
and over again, such as the exercises in
this chapter. They will quickly become
second nature and be perfected without
thinking. This will enable you to progress
rapidly to more complex work.

The first method involves building up
layers of paint, where the greater the
number of layers, the deeper or stronger
the colour.

The second method involves using
distance to create a more diffused, more
subtle grading of colour. Again, several
layers of colour can be applied, but
where the movement is further from the
surface, the colour diffuses more, but
remains more concentrated when the
movement is closer to the surface.

Simple shapes project

In this simple project, you will gain a
better understanding of what a positive
and negative stencil is. Also included is
a Technical Data Chart that will inform
you of the type of airbrush, nozzle size
and pressure used, together with other
practical information.

Having accidents and making
mistakes

We all have bad days and sometimes the
most experienced airbrush artists will
get even the most basic things wrong.
Here are some examples of what to try to
avoid and what has caused them to
happen:

Now you have had the chance to learn

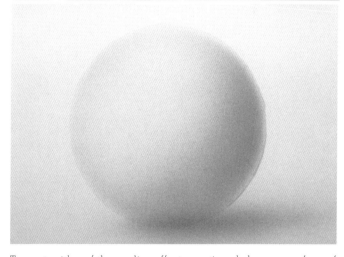

To create either of the grading effects mentioned above, some form of
mask is useful to create a sharp edge around the shape, in this case a
sphere/ball. You can cut a piece of paper, frisket film or use the
inside of a roll of tape.

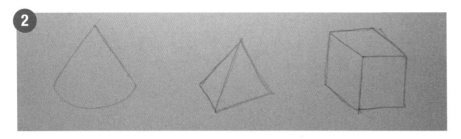

Draw and cut some basic shapes (about 5–10cm in size) on some plain paper.

some fun, simple techniques, all of which you will find useful in future projects. There is no substitute for practising what you have learned, over and over again. There is a general consensus of opinion that an 'expert' is someone who has experienced at least 10,000 hours of doing something. If you have spent the last hour doing the exercises in this chapter, then you have only got another 9,999 hours to go before you can qualify as an expert! However, by following the exercises and projects in this book carefully, you might just feel like an expert much quicker than suggested!

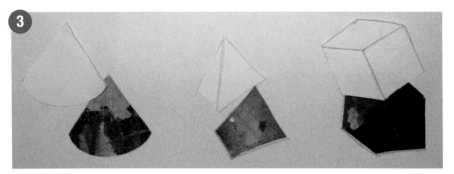

Carefully cut out these shapes with a craft knife, making sure you keep the negative piece (outside) and positive piece (inside).

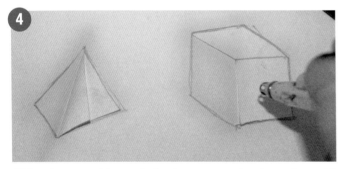

Using the cut positive masks for the more complex shapes (pyramid and cube), replace over your work and lightly spray in over the new edges.

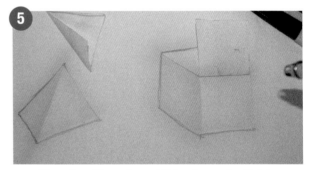

The cube will need an additional top edge lightly airbrushed in, using the positive mask folded on its edge.

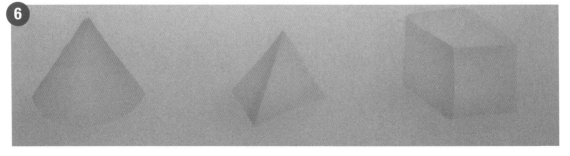

The finished basic shapes, together with a little freehand shadowing added at the bases of the shapes; this helps to lift the objects off the surface.

Here, too much paint has been applied too quickly and from too close a range. This could have happened as a result of being caught out by some poorly mixed paint coming out too quickly; more usually, however, this problem is due to individual control of movement – getting the distance and speed correct for the amount of paint being applied.

In attempting to cover a larger area too quickly, the paint has begun to 'pool', resulting in an uneven, blotchy finish. The key is always to apply each coat as dry as possible. Do this, and this kind of accident will be avoided.

As with the previous picture, too much wet paint will cause problems. In this case, even with a masked edge a problem has occurred. With frisket film, the surface of it should be applied firmly to the surface so the edges are stuck down. Paint will not then get under the edge. Even so, paint still needs to be applied in thin, dry coats.

Having this happen can be utterly soul destroying, especially if you have ensured you applied the paint correctly and masked everything up thoroughly. This has happened because a greasy finger mark was left on the surface and then sprayed over. This mistake sometimes reveals itself only when any masking is removed, as the 'stick' takes up the paint that is over the mark. A simple solution is to clean the surface down. With porous surfaces, simply scrubbing talc over the whole area and wiping down after with a tack cloth will prevent this. Non-porous surfaces can have a form of de-greaser (panel wipe) gently rubbed over the surface.

A broken line when a continuous line is desired could be the result of any number of problems: a slightly blocked nozzle; too thick a paint mixture; a poor compressor failing to deliver a constant flow of air – these are the main culprits here.

Grainy or spattered paint is most often the result of a paint mixture being too thick for the air pressure being used. Alternatively, it could be the air pressure is too low or the needle is damaged.

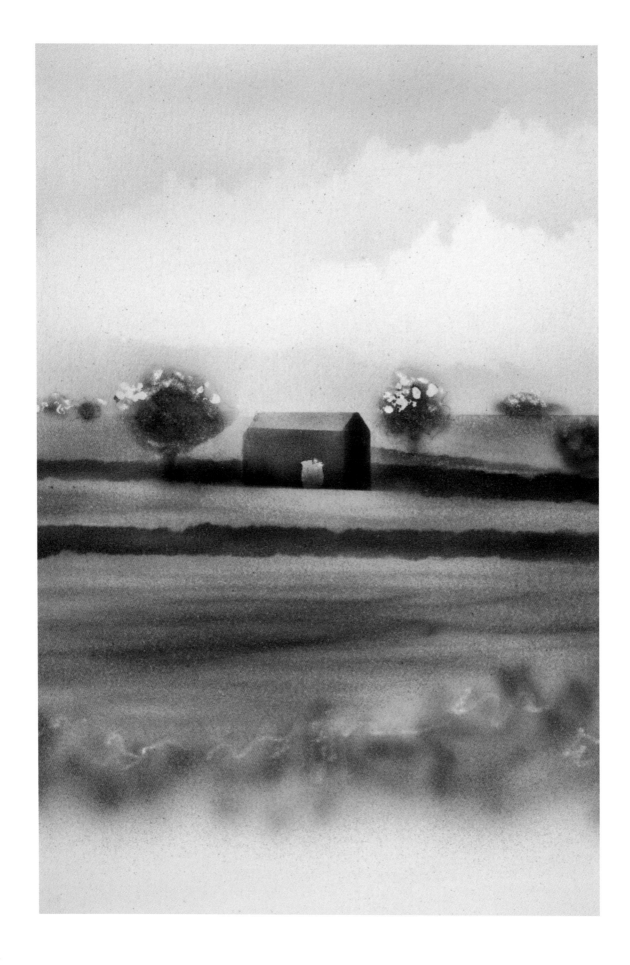

Chapter 5
Projects for beginners: Landscape and still life

When it comes to starting a project, there are no hard and fast rules. Being an artist means you do not need to be restricted by rules and regulations: you have 'artistic licence' to do as you please, interpreting an outcome as you see fit. In airbrushing, however, there are certain rules that should be observed, but these rules may be regarded more as guidelines that can be used or ignored on merit for each piece that is done. The important thing to remember in airbrushing is that there is an easy way and a difficult, more complicated way of doing any job. You should always endeavour to keep whatever you are working on as simple and straightforward as possible. The fewer processes and steps there are, the less chance of making mistakes or having to repeat masking and painting un-necessarily. The key, however, is planning: you should always have a clear idea of the process by which you are going to tackle the project you are working on.

Where to start

Whilst not written in stone, you should always begin a project, when applicable, in the background. Imagine each distant plane as a layer, progressively coming forward towards the viewer. In an ideal world you would plan to start in the background and gradually, layer by layer, work your way forward. If it is just a single object with no background per se, you should plan the work to start with the largest areas first, then build up on top of these with greater and greater detail.

Regardless of whether you are an artist or not, having a starting point from which to work is vital. Rarely can anyone just go into a piece of work completely cold and unprepared; only the most imaginative, talented and experienced artists have an ability to do this. Your starting point can have a variety of sources. A photograph, print, photocopy, line drawing (your own or someone else's), carbon trace or traced outline or projected images are all ways to get started. Whatever you do, you will inevitably create your own unique version and interpretation in completing the final image. When it comes to creating your own compositions, it is useful to have access to a wide variety of reference material, especially of a subject matter that is of relevance to you. What often makes an effective overall piece is your ability to demonstrate a variety of edge qualities. In this next exercise, various techniques for creating edges will be demonstrated.

PROJECT 1: LANDSCAPE USING WATERCOLOUR AND SIMPLE MASKING TECHNIQUES

When it comes to finding inspiration for painting a landscape, often you have to look no further than outside your own window. The picture I am about to demonstrate is the view that greets me each morning from my bedroom and studio window. The gently rolling hills around the Severn Estuary around the Royal Forest of Dean have their own unique beauty and a view that many would be grateful for. If you don't have a view like this and only have the next-door-neighbour's collection of rubbish bins to look at, painting this can nevertheless be rewarding in itself, as it will throw you a number of different challenges to contend with. The Photorealist movement from the 1960s had artists painting the most mundane subject matter, but executed with such precision it had to be appreciated: details were included that left the viewer astonished at the level of the human skill involved.

To keep things simple to begin with, we shall attempt to recreate a more traditional watercolour painting. You can use watercolour paper or indeed any kind of paper or board for this exercise. In this exercise, ordinary mount board has been chosen for its good paint absorption qualities. Dr. Ph. Martin concentrated watercolours are used.

LEFT: *View over Mitcheldean* by Fred Crellin. Liquid watercolours onto mount board. 40 x 15cm approx.

Airbrush	Paint/Medium	Surface	Tools/Materials
Independent D/A	Liquid water colour	White mount board	Toilet tissue
H&S Infinity	Pencil	*or any other suitable	Scrap paper
0.2 nozzle size			Liquid latex mask
15-20 PSI pressure			Electric eraser
			Masking tape

TECHNICAL DATA

Here, a selection of five colours has been chosen, including the three primary colours, grass green and sepia. Try to get into a habit of not using black, as this colour will often suck the vibrancy out of any colours you want to paint. Instead, create deep colours by mixing colours together. In a palette, mix together a small quantity of true blue, sepia and a small quantity of scarlet. This will give you a colour that at first looks black, but is not. Instead, it is a more neutral grey colour, with a hint of the predominant colour you used to mix it in the first place.

Using an ordinary pencil, gently sketch out your landscape picture. Do not press too hard as you may want to remove any pencil lines afterwards, and your pencil might leave an ugly indentation in your surface.

To begin painting the clouds, a mixture of scarlet and true blue has been mixed together. Because the colours being used are concentrated, it is important to remember, where necessary, to dilute the colours with water. However, to counteract the watery nature of the paints being used, you will need to reduce your air pressure to between 15 and 20psi. Gently freehand in the darker areas of cloud where necessary.

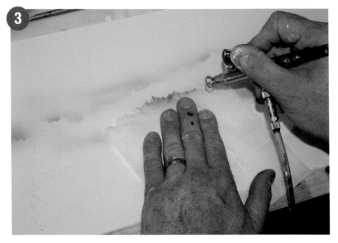

When airbrushing, change your colour by adding some of the darkest colour mixed, as already described. Let's call this 'not black'. Here, the detail in the edge of the clouds can be added. The quickest and most effective way of doing this is by using ordinary toilet tissue paper.

By spraying over the top of a carefully torn edge, you can create the most exquisite detail with ease. Do not worry if you get some overspray over where the trees and horizon line are. You will be able to use this overspray to good effect in the next stage.

Carefully apply a very small quantity of liquid latex in spots at the tops of the trees. This mask will protect the already painted sky, letting it show through the thinner areas of trees, adding greater detail. Apply this latex using a silicone-tipped brush. Do not use an ordinary bristled brush as it will become ruined quickly. The silicone tipped brush can be cleaned easily, as the latex peels off.

Now using a mix of grass green and sepia, begin 'blocking in' the trees in the background, using suitable edge shapes for each tree. Always take care with your positioning and ensure you are spraying over the paper edge and avoiding any spray getting under the edge.

Using a build-up of colour, deeper tones of green can be achieved, giving variety of tonal value in each tree. You can, should you wish, apply a deeper green colour over the top by adding either a touch of blue or sepia to your green mixture.

Once your surface is dry, carefully remove the latex from the surface with a clean, dry piece of tissue. You will be left with a clean, hard edge within each treetop.

Carefully fold and crease a piece of scrap paper and tear along it. This straight torn edge will give you yet another quality of edge. In this case, the horizon line where there are no trees can be applied using pure grass green from the bottle.

This same edge can also be used to create the hedgerows between the fields. This time, now using pure sepia from the bottle, spray the tops and bottom edges of these hedgerows.

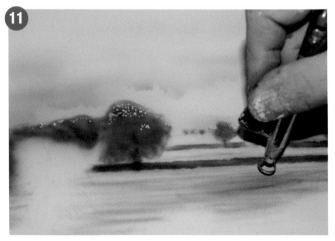

Your painting should now be taking shape. The sky is in, as is the detail at the horizon and other key features such as the hedgerows. Using the sepia again, freehand in some lines from close range for the ploughed and furrowed field. This will be worked over again shortly, as here only the darker tonal values are being added first.

Mix a small quantity of yellow with a touch of sepia in it. This will give the colour of the fields in the picture. This can be applied freehand over the required areas.

A solitary hay barn lies in the centre of the picture. Rather than having a fuzzy, freehand object in the centre of our picture, a more focused feature can be made of it by using some masking tape. This tape will give a relatively crisp edge to the outer edge of the barn. Using firstly sepia, then 'not black', together with the edge of a scrap of paper, airbrush in the sides of the barn. You will also note that a small amount of latex mask has been applied to create the doorway.

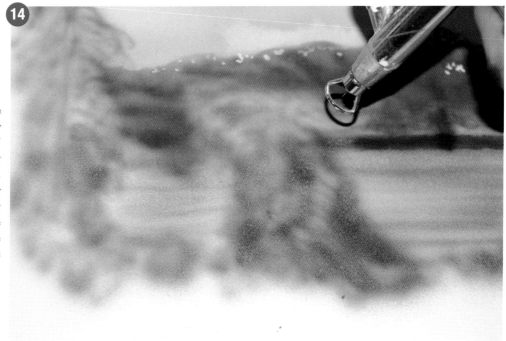

Now the foreground can be added. As the foreground merely serves as a method of 'framing' the picture, it does not matter that it is slightly out of focus. This can be achieved by spraying the grass green colour freehand at close range. The treetops of conifers and apple trees will help draw you into the picture.

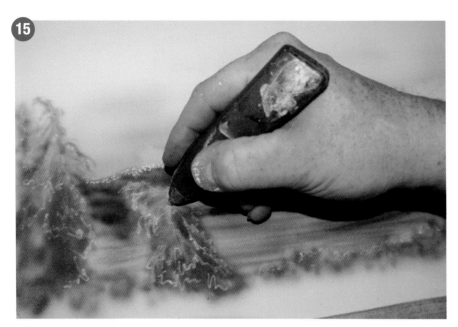

Finally, using an electric eraser with a hard tip inserted, remove small amounts of paint from all the trees in the background, middleground and foreground.

TIP

USE 'NOT BLACK' FOR DARK AREAS

Using 'not black' is one of those little things that can completely transform your work. In nature pure black rarely appears. Black in the conventional sense is nothing more than an absence of light. If you disagree with this, have a really close look at something that on face value is black under a strong light. Even coal has a blue tinge to it; a dog's nose may appear slightly brown or even purple. To darken a colour, black really should be avoided at all costs: black will deaden the colour, rendering your picture lifeless. To create a transparent 'not black' of your own, try combinations of the darker colours available in your palette. You can use any combination of sepia, purple, umber, ultramarine and cobalt blue.

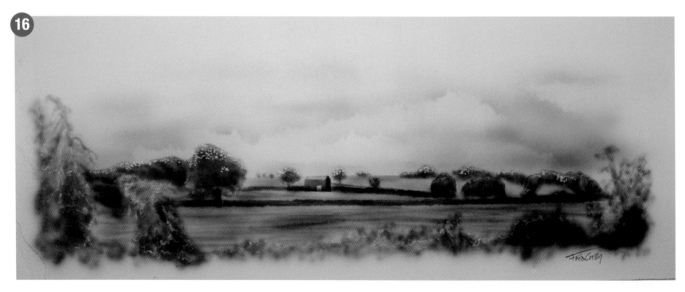

Don't forget that as this is watercolour, ideally it should be displayed behind glass or kept in a portfolio or book, as weather conditions and temperature change can cause your work to deteriorate.

Airbrush	Paint/Medium	Surface	Tools/Materials
H&S Evolution	Liquid acrylic ink	Schoellerhammer 4g	Frisket/Masking tape
0.2mm nozzle size			Eraser pencil
30-40 PSI pressure			Electric eraser
			Knife
			Pencil/graphite

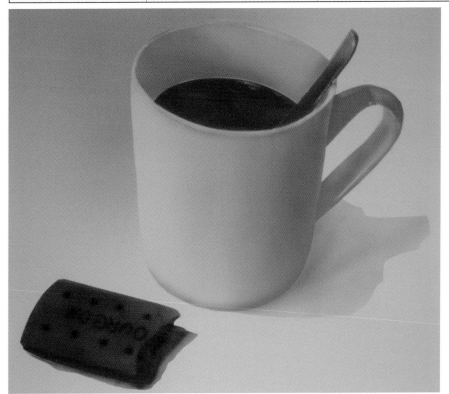

Cup of Tea: liquid acrylic onto airbrush paper, 30x40cm approx.

PROJECT 2: EXERCISE FOR BEGINNERS USING FRISKET FILM

Inspiration for producing work can be found in the unlikeliest places, often much closer to home than you think. In this exercise, the inspiration was taken during a break wondering what would be the inspiration for the next piece! A simple cup of tea and biscuit are the subject of this next exercise, which will take you step-by-step through the whole process. All you will need is some art board or airbrush paper, frisket film, craft knife, a soft and hard pencil, and tracing paper.

TIP

CUTTING FRISKET FILM

When cutting frisket film on a surface, it is important that the surface itself is not damaged with deep cut marks. You can achieve this by altering the way you hold your blade. By placing a finger actually on the side of the blade as you are cutting will enable you to 'feel' the material being cut. You should, with a little experience, be able to distinguish the different feel of frisket compared to board or paper and gauge the correct pressure that needs to be applied.

Here, the image of the cup of tea and biscuit has been drawn onto tracing paper with a hard pencil in line form. Include an outline of any shadows as this will add an extra dimension to your work.

Turn your tracing paper over and using the soft pencil, scribble all over the back of your work. This method is known as a carbon trace. You could alternatively use carbon paper, but the impression that leaves can be too harsh a line on your surface. This method will give you a clear, visible line that is not too strong and can be easily erased if required.

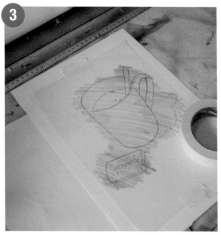

Turn your tracing paper the correct way round and place over your airbrush paper or art board. To make sure the tracing paper does not move, use a little masking tape or even a scrap piece of frisk to hold the tracing paper in place (or even a magnet if your work is on top of a steel sheet). Now re-draw over the top of your existing pencil drawing with a hard pencil.

You should now have an imprint of your image directly on the surface to be painted.

Cut a piece of frisket film to the size of the paper you are working on. Remove the backing by placing a small piece of masking tape on a corner. This method makes removing the backing easier. Do not throw the backing away: you will need it to keep components of the image as they are being cut and replaced. Smooth the frisket to the surface by rubbing down with your hand, pushing from the centre out towards the edges.

Now carefully cut all the frisket film on the surface. You need to avoid cutting into the board or paper, and only score the frisket film with a sharp blade.

Now you can begin removing elements of the image. Here, the darkest part of the image is being removed first; in this case it is the shadow on the handle of the tea cup. When you have removed it, place it nearby on the frisket backing you have kept. Doing this will increase the life of the frisket and ensure the 'stick' on the frisket does not deteriorate to a point that it becomes unworkable. Frisket film is designed as a low-tack, removable film. However, it can only be applied a few times as the tack quickly wears out.

The colour that has been mixed for this exercise is a combination of black, white and purple/violet ready-mixed liquid acrylic ink. Here, a flat, strong tone is sprayed into the exposed area. It should reach saturation point (the point at which the white surface no longer becomes visible).

The next section of frisket film from the handle is removed. This time, tones of colour are applied instead of a flat tone. This should be sprayed in accordance to where there is light and shade on the handle.

To bring back some of the reflective highlighted areas on the handle, paint can be gently scraped from the surface using the blunt edge of your knife. Carefully scrape back to the white of the board in the necessary areas. You may wish to replace the cut-out pieces of frisket to protect what you have completed.

A small section of frisket is removed, behind the teaspoon and next to the handle. This dark area is airbrushed in using a strong tone of colour with just a hint of fade.

Now remove the rest of the inside section of the coffee cup (excluding the top rim of the cup) and spray a graded tone showing a good contrast of light and shade.

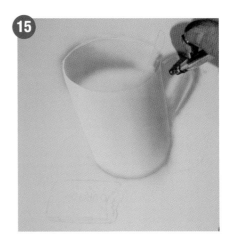

Now the thin sliver of frisket can be temporarily removed and gently airbrushed in. Note that this piece has not been completely removed. This is to make replacing it in the correct position easier later on.

Once again, using your scalpel, remove paint from the highlighted edges at the rim of the cup by carefully scraping away.

Now remove the frisket at the main front of the cup and spray a graded tone according to the light and shade. Don't forget to keep this piece of frisket as you will need it again later. Note how a stronger line at the base of the cup has also been sprayed. The top rim has not been cut and another sliver of frisket has been left in place at the top rim of the cup. Once the front has been completed, the top rim of the cup can be sprayed. Carefully remove this thin line of frisket film, then spray a subtle, light amount of paint that grades lightly from one side to the other. The scalpel can be used afterwards to add highlight details.

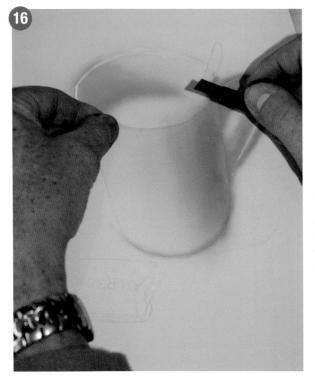

Using the main front piece of frisket from the cup, replace it in the correct position. Ensure you have lined it up correctly or you will end up with an ugly double-edged line that will spoil the overall look of your picture.

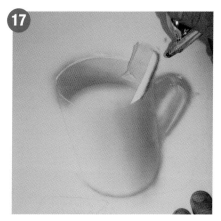

There is nothing stopping you from adding additional masking if you feel what has been replaced is insufficient. Here, a small piece of masking tape has been used to complete the top edge of the spoon. The frisk for the actual spoon is removed and a new colour is used. A mixture of black and white is mixed to create a neutral grey colour. It is quite common to add just a hint of colour (the mixed purple used earlier) into the colour mixture that will help tie the whole picture together. Firstly, the darker areas of the spoon are airbrushed in, followed by the lighter areas using the same colour.

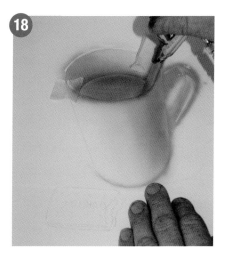

Ensure all masking is put back in place for the cup itself and that no areas are left exposed. Unwanted overspray at this stage would be annoying and a difficult error to correct. Using a third colour made up of yellow, orange, white, sepia and purple, the colour of the tea can be sprayed. Rather than airbrushing just a flat tone, add a little variation to the surface of the tea by adding shadowed areas.

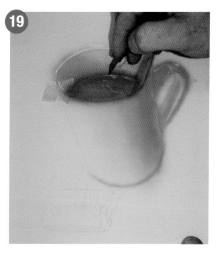

Once again, scratch away reflective areas of the tea surface. These can be repainted/tinted with a little more colour afterwards.

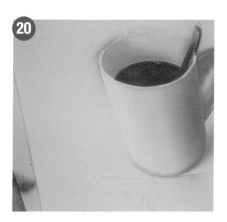

All the masking for the cup is then removed and checked for any errors such as unwanted overspray, incorrectly placed highlights and shadows and imperfect edges. These can all be repaired or rectified by rubbing away at the errors or re-airbrushing over the top.

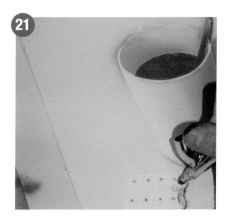

The 'biscuit' frisket area is removed and initially the darkest shadowed areas are painted using a sepia colour. This includes the indentations, shadows and text on the biscuit.

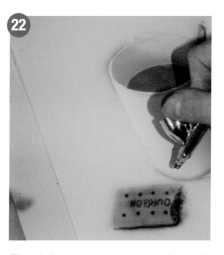

The whole biscuit is then tint washed with the sepia colour to begin bringing the correct tonal values into play

Now that the tonal values have been established, another transparent colour is mixed to the colour of the actual biscuit. Here a combination of sepia, burnt sienna and purple are used. This is sprayed relatively evenly over the whole 'biscuit' area.

An area of frisket is removed where the shadow is cast on the surface. Reverting back to the colour mixed previously that was used for the shadow of the cup, spray a graded tone which is stronger at the edge of the biscuit but fades to the outer edge.

The biscuit and cup are now complete. A little work now needs to be done to the background, which will help pick out the lighter left-hand side of the cup. In this photo, you can see that the left-hand side of the cup is actually darker than the background. This needs to be changed.

The outer frisket from the picture is completely removed and new frisket placed over the painted areas. The outside edge of the cup and biscuit are re-cut and the outside area of frisket removed to reveal the white background.

Using the same colour used for the cup, spray from a greater distance a light tonal value over the left-hand edge of the cup onto the background, until it appears darker than the cup itself. This will help pick out the cup and make it appear to stand out from the background. Finally, remove all traces of masking from your now completed picture. Note how the images leap out from the page and look three-dimensional. This is largely down to the light and shade used on the objects, but primarily down to a clever, but subtle use of shadowing in the background.

Chapter 6
Using everyday objects as masks

The next time you go shopping, really open your eyes and have a look at different packaging materials and products, with a view to what effects you could achieve if you airbrushed through it. Even the most common, mundane materials can be used to good effect. The trick with using any of the suggested products being demonstrated here is to spray at exactly 90° to the surface you are spraying, and that the paint goes on in very dry, thin coats. You do not want your 'found' mask to start dripping wet paint all over your surface.

In this chapter, you are given some step-by-step guides to creating what can best be described as 'art in a minute'. This process is very quick and very easy!

Coins

Place a collection of round coins onto your surface and lightly spray a colour (any colour).

Move the coins around and then lightly spray over a secondary (different) colour. Remove the coins. You should have a simple piece of art where colours and shapes merge into each other.

LEFT: One-minute masterpiece using found masks.

Fishnet stocking

Tape some old fishnet (or any patterned) stocking. You will need to stretch it out in places to get best results. Spray a colour over the surface from about 10–20 cm away, ensuring you remain at 90° to the surface. Your spray should hit the surface virtually dry. You should not move the stocking mask during this process.

Carefully remove the taped stocking from the surface. If you are not sure how dry it is, give it a minute or two to dry off before removing.

Lace

Here some lace and voile have been held down with magnets. The surface lies on top of a steel plate. Masking tape has also been used to create two hard edges. A medium skin tone is graded with the airbrush, stronger on the outer edges, fading to the centre. A little purple is then sprayed over the outer edges to deepen a 'skin' tone.

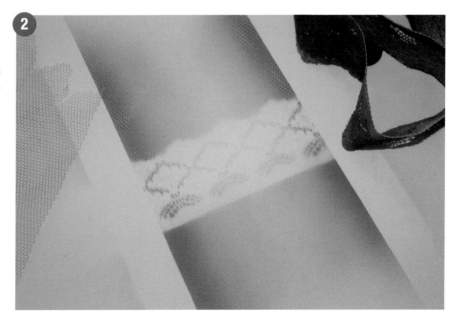

When all the masking is removed, the finest details can be seen.

Other materials

A selection of ideas and outcomes for
you to try is shown here.

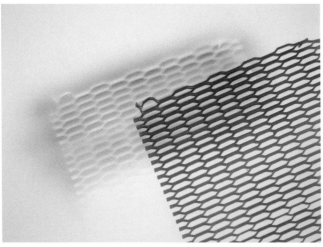

Plasterers' reinforcement. The pattern created by this can be good
for creating faux gridwork on vehicles or even snakeskin when
viewed at an angle.

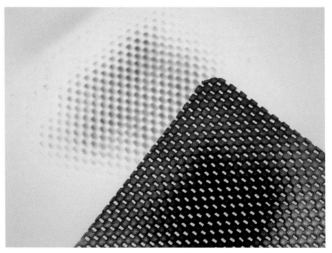

Anti-slip matting. This is great to mimic carbon fibre effects. You
can also use some carpet underlays which have a similar property
to this material.

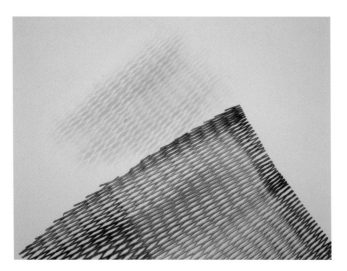

Plastic netting. Often used to carry/package bulk vegetables, this
material is ideal to create snakeskin effects.

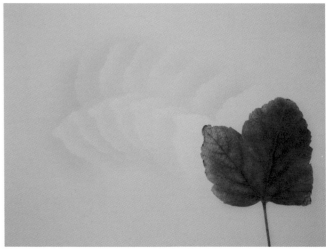

Tree leaf. Let your imagination run wild and try spraying repeat
patterns using various colours to create some novel and unique
artwork.

Evergreen leaf. The finer, smaller individual leaves from this tree can give much greater detail. Useful in forest-based composition artwork.

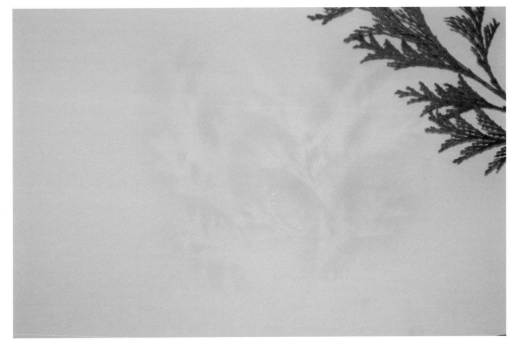

Even grass can give fascinating results that can help landscape compositions. When spraying this, spray along the length of the grass instead of across it as it has a tendency to blow about.

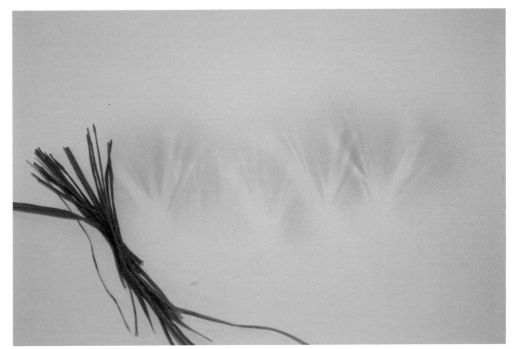

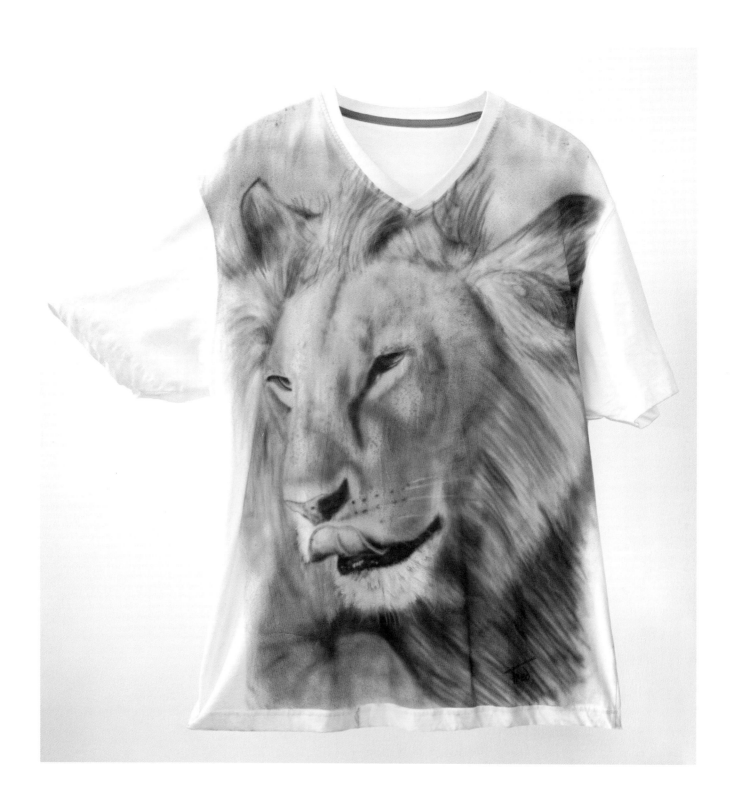

Chapter 7
Freehand airbrushing a lion onto cotton

Airbrushing onto some surfaces can bring greater challenges than first meet the eye. Paper, card and board are all relatively straightforward and can give the most exquisite detailing to a photorealistic level, even under close scrutiny. This is largely due to the fact that the actual surface you are painting on is smooth and won't move about.

Cotton, on the other hand, will give you a whole new set of problems to overcome. Firstly, the surface is finely textured and highly absorbent. Secondly, because the fabric is not fixed or stretched in any way, it has a habit of moving about when touched. Lastly, because of the nature of what is being

painted, the pigment that goes onto the surface must also be able to withstand the rigours of washing.

The cotton should be properly prepared ready for painting, firstly by washing it, then ironing it flat and attaching it to a surface. In this example, a rigid piece of Foamex board cut to the

Airbrush	Paint/Medium	Surface	Tools/Materials
Independent D/A	Liquid acrylic	Cotton	Projector
H&S Evolution	Clear base extender		Pencil/graphite
0.2mm nozzle size			Iron/heat gun
H&S Colani			Baking parchment
0.8mm nozzle size			Masking tape
50-60 PSI pressure			Paste brush

TECHNICAL DATA

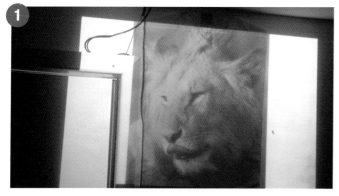

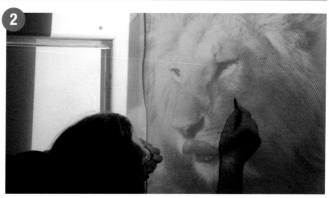

The digital projector being used in this photograph can be used to great effect when starting large pieces on walls or panels such as fairground rides and trucks. However, even small pieces such as a T-shirt are ideal to be projected onto. In this, the actual photo reference is projected and a detailed line drawing is drawn onto the surface. As an alternative to a digital projector you could use an overhead projector. Whatever you do use, ensure it has the capacity to focus the image clearly and give you the option to change the size of the image being projected. For larger images, a powerful bulb will be required. Also ensure that the image being projected is 'square-on' to the surface or the image will become distorted.

Here, a stick of graphite is used, but a soft pencil is just as good. Ideally, try to put in as much detail as is possible, as you will be relying on this later when you attempt to freehand airbrush this piece. Alternatively, you could choose to airbrush directly over the projected image with a subtle colour in keeping with the piece being attempted.

LEFT: Lion on t-shirt by Fred Crellin: acrylic with fabric additive on cotton. Photo by Colin Mills

size of a T-shirt was used. A light covering of a spray adhesive (3M spray mount) was applied to the Foamex board on one side. The T-shirt was then slipped over the board, positioned so the cotton was flat and not stretched in any way and ironed again onto the board on a low heat. The spray glue helps to hold the cotton in place. As this piece is entirely freehand, there is no masking to be prepared. Instead, the image will be projected onto the T-shirt.

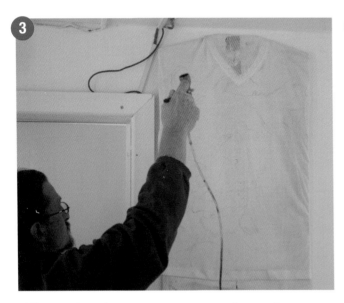

When you have drawn out your image, you then need to prepare the top surface ready for painting. Here, a clear base extender by Medea is being sprayed liberally over the whole surface to be painted. This medium not only helps make the garment more washproof, but also helps make the surface being painted a little flatter, by sealing in tiny cotton strands that naturally sit proud of the surface. Once this has dried, it is also a good idea to iron the surface again, using some greaseproof paper between the iron and the cotton surface.

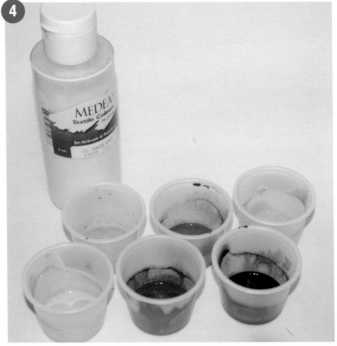

The paints being used for this exercise are a combination of different liquid acrylic paints but with some of the clear base extender added into it. This medium will help encapsulate the colour pigmentation making it more wash fast. For this piece, six colours have been premixed that will be used as the colour palette. The deepest colour, however, is not black. Instead, a combination of sepia, burnt sienna and violet has been mixed to give a very deep colour. This trick of not using black is a useful one to know if you want your overall images to look more realistic. We will call this special colour 'not black'.

5

Here the surface has been prepared fully and is now ready for painting. You will notice that the graphite/pencil lines are quite visible at this stage. The sleeve seams, neck seam and bottom hem have also been masked up so the picture will have a hard edge in these places. This will help frame the finished piece and make the whole garment look neater and more professional.

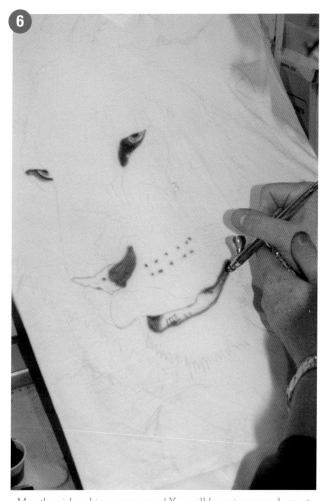

6

May the airbrushing commence! You will be using your deepest colour to begin with, as this will help start mapping out the key features of the eyes, nose and mouth. As you will be working completely freehand, you will need to work at very close quarters to the surface. A build-up of unwanted overspray would be very difficult to fix. The downside to painting cotton is that any major mistakes cannot easily be rectified. Another factor to consider is the air pressure you will be using to paint this garment. As the surface is highly absorbent and not entirely flat, the paint needs to be 'injected' into the fibres. Any light, dusty airbrushing is ineffective on this surface as it would become lost in the fibres. To counter this loss of detail, use a higher air pressure that will encourage the paint to embed itself within the fibres of the cotton.

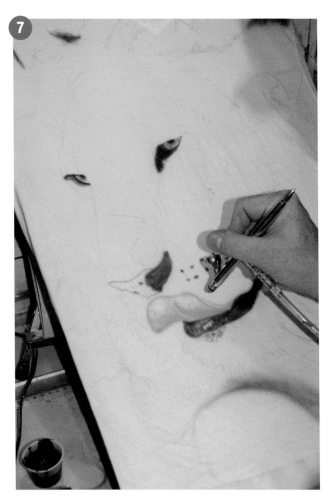

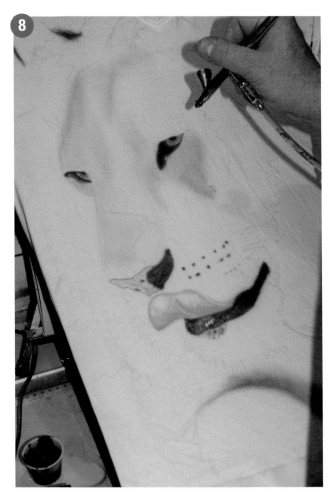

Using the pink colour, the tongue is airbrushed in. Note that the wet highlight areas of the tongue have been left white. To give an idea of where the darker tonal colours will be placed, a greater quantity of the pink is built up in these areas at the bottom of the tongue. The nose is also lightly painted in too.

The lightest fur colouration is used first in the lightest areas to begin with. The eyes are lightly tinted to start the process.

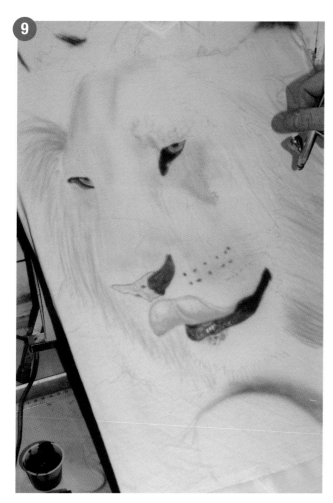

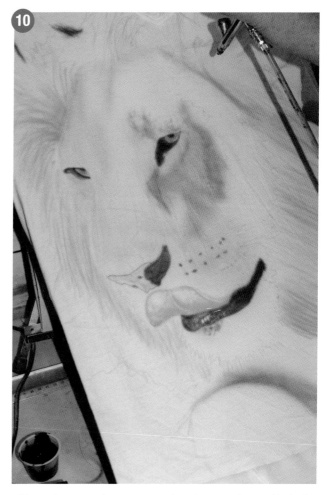

Still using the lightest of the fur colours begin mapping in the strands of hair that make up the mane of the lion. To do this, work quickly creating lines from close to the surface, as you did in the beginners warm up exercises. Remember to start your stroke at the root of the hair and keep your hand moving even after the painted stroke has finished. This will help you achieve the fine point of a hair as opposed to a heavy dot at the end which would spoil the effect.

Using the next colour in your palette (getting deeper/darker), begin working on the next area of the lion's face. As this part of the face is partially in shadow, the tonal values will also become darker. In this piece, you should ideally work progressively from lightest to darkest (but starting with a dark outline and a bit of shading doesn't count). Do not worry too much at this stage about individual hairs as this will be added in at the next stage. This section mainly acts as a foundation for subsequent painting.

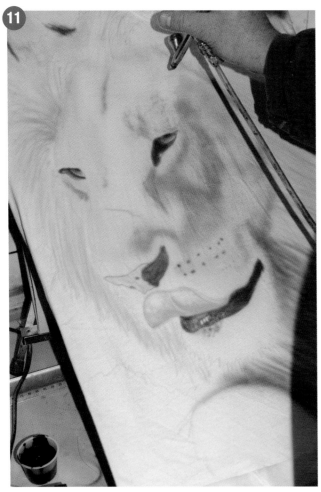

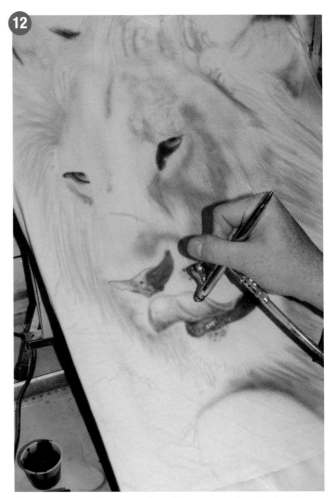

This colour can be used as a marker for the next colour to go down. By layering one deeper colour over another helps give the whole picture more depth and contrast. However, another good reason for employing this method of painting is that it help give you a better overall 'overview' of the progress you are making, a bit like watching a photograph develop in its solution. Because you are also using a colour that is a tone lighter than intended, if you make a mistake or change your mind about the depth of colour, little or no damage is done.

Greater contrast is now put into the tongue using the dark brown colour. To keep a good contrast of light and shade, ensure that areas of the tongue have almost white and almost black areas. This creates a better impact and stops the whole picture becoming washed out and muted.

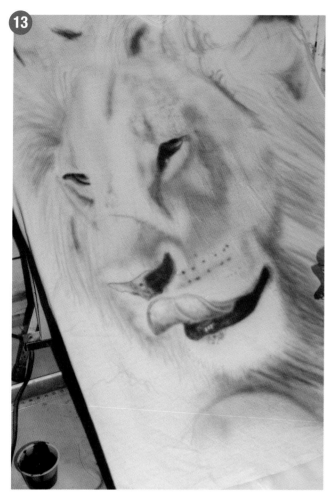

More of this brown colour is then applied in areas of shadow around the side of the face and nose. Areas of 'not black' are also reworked over again helping to deepen them, such as the nostril and lips and eyes.

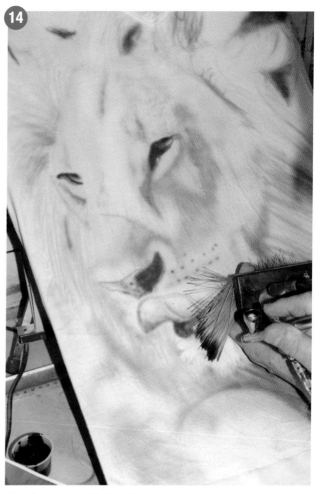

Here's a clever trick. As this is a freehand image and we are not cutting any masks or templates, other tools and techniques can be employed to create greater detail in the fur. Here, a coarse wallpaper paste brush is used to mask out where the white hairs on the chin are. Using the 'not black' colour spray the shadow under the chin. The brush acts as a positive mask. By carefully spraying the tips and in between some of the bristles, animal fur can be mimicked very quickly.

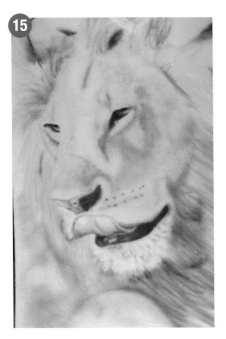

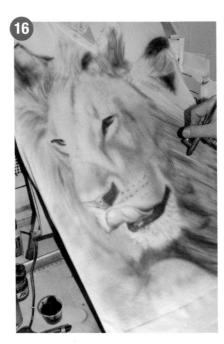

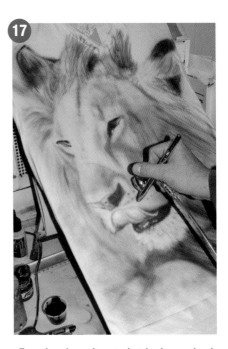

This is what the chin should look like when you have completed this little technique. Notice that not only the bottom edge of the chin looks as if great detail has been applied, but also areas actually on the chin itself. This has been created merely by moving the paste brush up the chin and lightly spraying small areas. Do not be tempted to go mad with this technique – it only really works in moderation. Less is more...

Using the 'not black' colour, rework the whole picture adding in shaded definition and detail to the fur and hair. Always refer to your photographic reference piece(s) to help you gauge exactly where light and shade should go, as well as texture and pattern. Work begins on the lion's mane to bring this into better balance with the rest of the picture; currently it looks too light in places and needs deepening with greater definition.

Fine details such as individual strands of hair and fur can be airbrushed in from close in, as well as details such as the markings and the root of a whisker. The fur at the top of the lion's mane is also given greater definition.

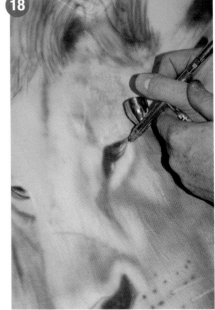

Now for a complete change of colour. Using pure white with the transparent base extender added to it, begin adding highlight details. This colour is used to rework the eye, putting in the finest of details such as a line of moisture on the bottom eyelid and a little reflection in the actual eye itself. Fur can also be reworked, putting in individual hairs and whiskers in areas that require it.

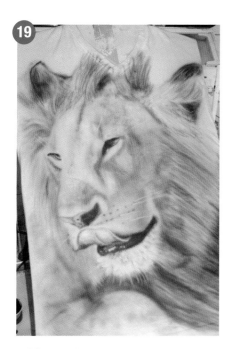

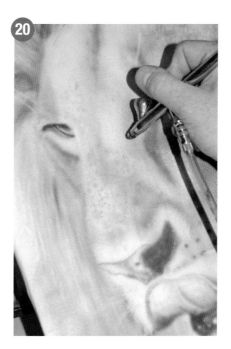

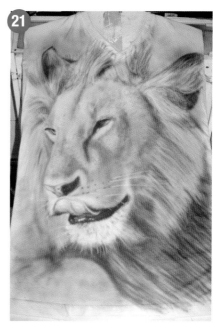

White is also used on the chin again, extending some of the longer hairs, and white is put back on the lip again where it may have become lost a little with overspray.

Pattern and texture can be put into areas of fur around the nose and forehead of the lion using a middle brown colour. Working in either short dagger strokes or even rapid up and down movements creating a mottling effect, detail will quickly build up to help the overall picture gain in detail and clarity.

To complete the picture, colour is added to the front paw and the background fuzzed out using the 'not black'. A little tinkering with the overall image will allow you to add further detail to the hair and fur, balance out light and shade and generally add more definition and detail where required. Making these final alterations at the end of the process is necessary in helping perfect the overall look of the piece.

The T-shirt is then sprayed again with a liberal coating of the transparent base extender and allowed to dry for an hour or so. You can use some gentle heat from a heat gun or hair dryer to speed up this process. Once dry, the whole painting needs heat setting to seal in the paint.

Using greaseproof baking parchment, run a hot iron over the whole image on both sides (inside and out).

As a guide, you should not really put the garment in the wash with other clothes, as modern washing detergents are too aggressive and will quickly break down the paint. Instead, use warm water with a mild washing detergent in a hand wash and allow to drip-dry. Respect the work you have done and it will last for years.

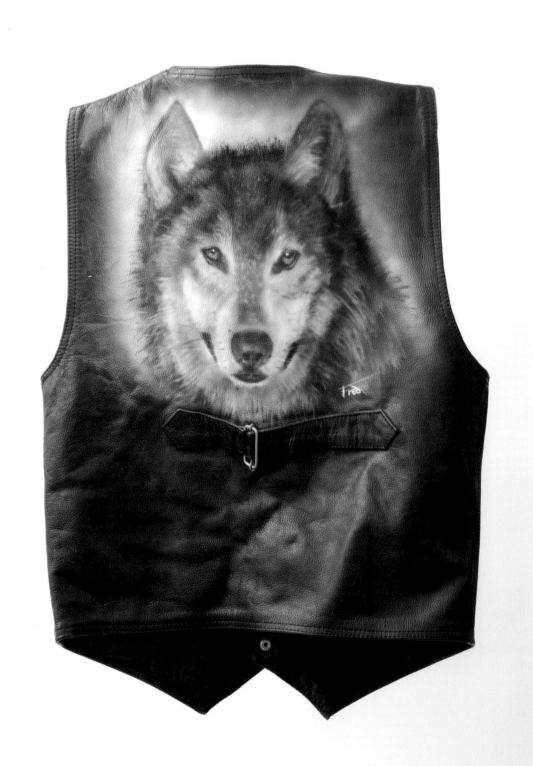

Chapter 8
Airbrushing a wolf onto leather

Even if you are not interested in airbrushing onto this particular material, you will find several exceptionally useful techniques in this exercise. Although primarily a freehand airbrushing exercise, there is a small amount of crude paper template work involved, just to get the project started.

This technique can be employed onto virtually any surface, as the actual image is only ghosted in, giving you the correct position, size, scale and shape of particular elements within the composition. In this case, the pencil

drawing has been traced from a photographic reference. Also, you will be working on a black surface with mainly white paint, and then tinting this white paint with transparent colour to tint it at the end.

Airbrush	Paint/Medium	Surface	Tools/Materials
Iwata Eclipse HP-CS	Liquid Acrylic Ink	Leather	Degreaser
0.35mm nozzle size	Medea Topcoat		Paste brush
H&S Colani			Paper mask
0.8mm nozzle size			Knife & masking tape
30-40 PSI pressure			Paste brush

TECHNICAL DATA

To begin with, the surface is stretched over a former. This leather waistcoat happened to fit perfectly over an old plastic sheet that had been cut into the shape of a T-shirt. The waistcoat was buttoned at the front and manoeuvred to sit flat on the board.

The surface is then degreased to remove old dirt, debris and other contaminants that may cause problems with paint adhesion.

This degreaser also removes a small amount of the natural colouring and oils held within and on the actual leather. This will also create a better surface for the paint to sit on and absorption will be further encouraged.

LEFT: Wolf by Fred Crellin: acrylic onto leather. Photo by Colin Mills.

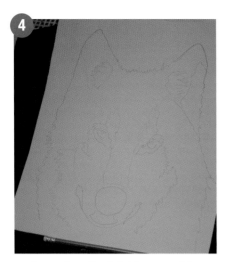

A pencil outline is laid on top of the leather to check for positioning and whether it actually fits the surface correctly. As this image is going to finish above the fixed belt line on the back of the jacket, this picture fits the space well.

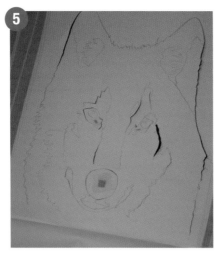

A loose paper outline is then removed and cut on a cutting mat with a scalpel. Do not attempt to cut this directly on the leather – that would just be asking for trouble! Not all of the lines have been cut, as you will want the stencil to remain largely intact so that you don't have small pieces floating about.

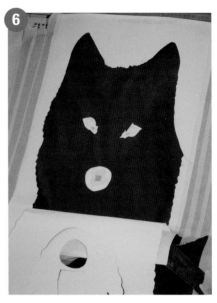

The eyes and nose have been held in place with a small piece of masking tape placed over a small square cut-out. This will help you get the correct position for the eyes and nose. As the eyes and nose are predominantly darker than the rest of the image, it makes sense to mask them out over the black leather.

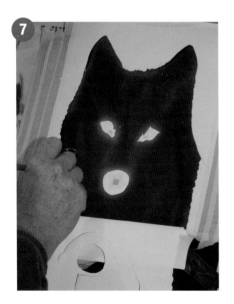

Now you can begin 'ghosting' in the main features. In this picture Hansa Pro-color white has been used, thinned with one part water to five parts paint. As this white will also be used to create much of the finer detail, it makes sense to thin the white a little more as it has a tendency to clog more frequently when trying to paint fine details.

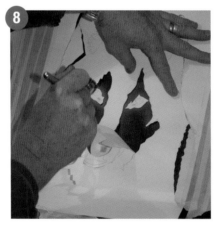

Further ghosting around the eyes helps denote where the fur markings will be placed. This should only be just about visible to the naked eye. The overall look of this piece is to make it appear free hand, with soft edges. As you progress in this picture, your masked edges will eventually disappear. By only putting in ghosted lines, these will be easy to cover as you go along. As with any masking, the trick is to use it as a starting point and not rely on it too heavily for edge work.

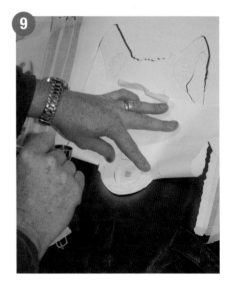

Reverse masking for under the jaw will also help you give a better overall view of the whole image. Again, only a light ghosted amount of paint is needed.

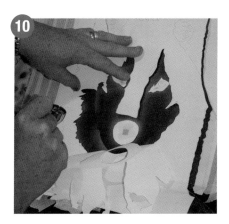

The final part of the mapping out in this exercise is the area between the eyes and nose. As the image has a darker stripe in this area, to ensure the stripe is in the correct position, a light ghost line is placed in the correct position using the paper mask.

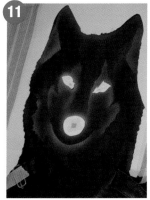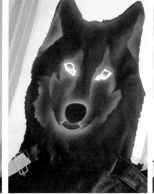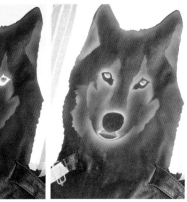

This sequence shows how finer details can be put in using the paper template. Here the mouth and eyes are added. Now you should have an image that can be freehand airbrushed, which will soften the paper edges and add greater definition and contrast.

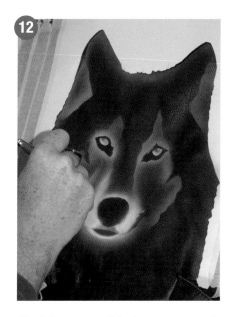

The lightest parts of the image are started, adding definition and lighter tones around the mouth. Because there is now no masking, you should be working much closer to the surface, otherwise you will get a build-up of unwanted overspray.

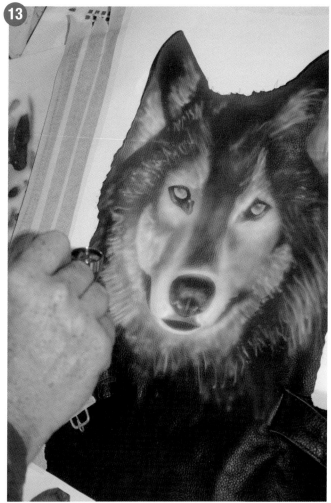

To create the fur freehand, you need to work very closely to the surface, starting at the root of the hair and ending at the tip. If it helps, you may wish to turn down your air pressure, thin your paint even more and remove the needle cap of your airbrush. You are still only using white paint at this point.

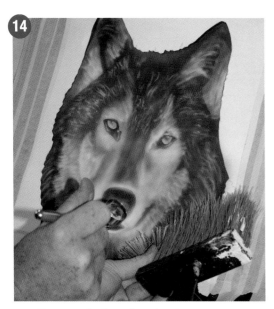

To create the fur in fine detail, use a course wallpaper paste brush as a positive mask. By bending the bristles in certain ways, you can replicate fur very quickly. Because the bristles on this brush are so coarse, they can be easily seen. This is particularly effective against black.

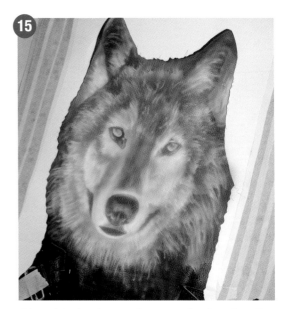

Most of the face has now been completed in white. You may wish to go back in again with black and then white to make small alterations to several areas so that the tonal balance is correct over the whole image, eliminating over-light and over-dark areas. So far, the background has not been touched, as this part still remains under the paper mask.

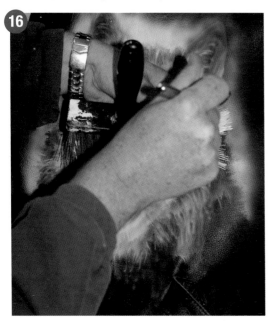

The paper mask has now been completely removed and the light background airbrushed in. However, to create an effective edge the paste brush is used once again to create the fur sticking out at the outer edges of the wolf.

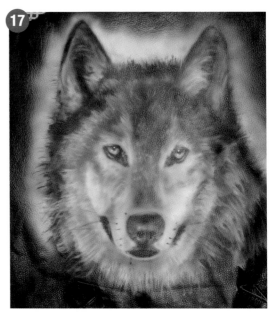

A lot of people would be grateful to get to this stage and call it quits. The created image is a very pleasing monochrome wolf that customers would pay good money for. However, this exercise is also about tinting a black-and-white image to convert it to colour.

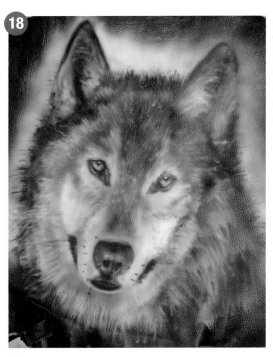

Using a mixture of Createx Wicked transparent yellow and transparent burnt sienna, lightly tint the eyes, the fur beneath the eyes, small sections of the ear and under the chin.

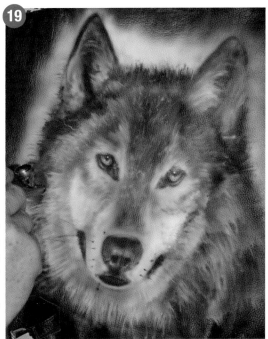

Never be frightened to go back a step if you think your picture needs some more definition or correcting. In this picture, further white fur detail has been added.

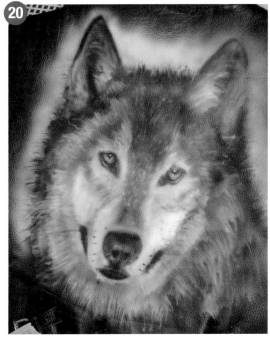

Using only transparent burnt sienna, rework the areas painted with colour, working both at close quarters and from a distance of about 5cm around the eyes, concentrate this colour only at the top of the eye where the colour is deeper.

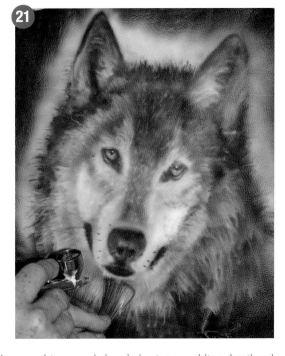

Finally, with more white, rework the whole picture, adding detail and definition to the fur in areas where it is needed. To create even finer fur details under the chin, the same technique has been employed as before, but this time using an ordinary decorator's paintbrush as a mask. The finer bristles will give a finer hair edge. This can be repeated in small areas around the whole image if required.

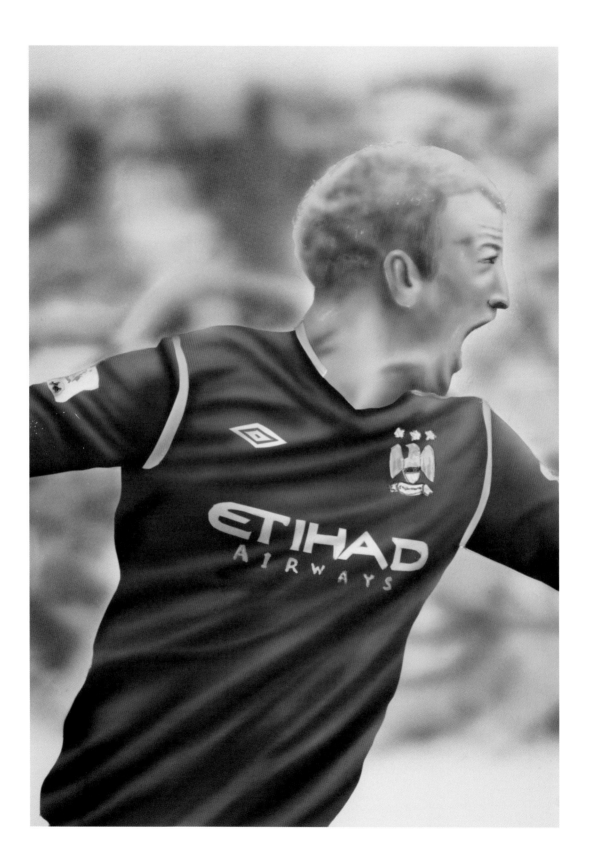

Chapter 9
A portrait using frisket film and a technical illustration

TECHNICAL DATA

Airbrush	Paint/Medium	Surface	Tools/Materials
H&S Infinity	Liquid acrylic ink	Schoellershammer 4g	Projector, tack cloth
0.15mm nozzle size			Pencil, paintbrush
20-30 PSI pressure			Frisket, electric eraser
			Knife & masking tape
			Latex, eraser pencil

PROJECT 1:
JOE HART CELEBRATES

Being an airbrush artist is not the only passion in my life: other than my family, my other passion is football and my football team, currently one of the most powerful and wealthy football clubs in Europe. To celebrate their win in the English Premier League in 2012, I embarked on producing a series of paintings that would be turned into limited edition prints and sold to fans of the club.

One of the subjects of my attention was the Manchester City and England goalkeeper Joe Hart. While the winning goal was going into the net at one end of the pitch, he was celebrating it at the other – an image that was caught on TV cameras amongst the ensuing pandemonium in the stadium.

With some clever in-house technology involving a computer, the internet and a projector, I was able to capture a still and recreate (with a little artistic licence) a pencil outline drawing onto Schoellershammer 4G card.

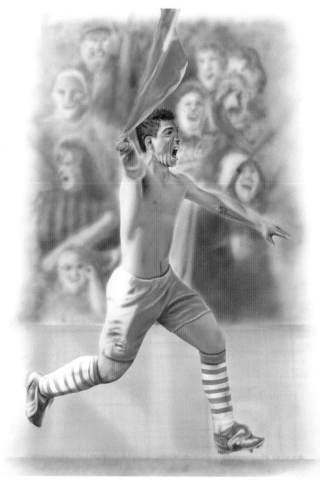

Sergio Aguero's Victory Run by Fred Crellin ©mcfcartist.co.uk

LEFT: *Joe Hart Celebrates* by Fred Crellin ©mcfcartist.co.uk.

Creating a pencil outline drawing.

1

 TIP

WORKING WITH FRISKET FILM

When you are using frisket film, it is good practice to keep as many discarded pieces as possible by storing them onto some spare backing. Only destroy or bin them when the whole job is finished and you are happy with the overall result. Doing this could save a great deal of time and additional material if you need to do any remedial alteration or correction work. You would have already gone to the trouble of cutting out 'masks' once, so it seems sensible to avoid having to repeat what often can be complex work.

2

Observing the rule of starting with the background and working forward, I began by creating a background for my painting. It is useful to have an idea of what colours to use for the background before you start. To make the background in this picture recede even further, a number of combined tricks have been employed. The use of more neutral colours that have been lightened and blurred all help the background recede and allow the focused character in the foreground to 'pop' and stand out. The background is sprayed without any masking aids and colour is applied without the airbrush getting too close to the surface. Remember that close quarters airbrushing will give a defined but soft finish. Here, all that is required is an impression of the jubilant crowd. No faces are discernible, but the use of two flesh tones, some colour, light and shade are all that are required. To make sure that the underlying pencil lines are removed, use opaque paint first to build up the colours and two skin tones. Light and shade is added afterwards to provide light, shade and contrast. If the overall background you produce is either too light or dark, you can always alter it by spraying the entire area with white or transparent black (Payne's grey).

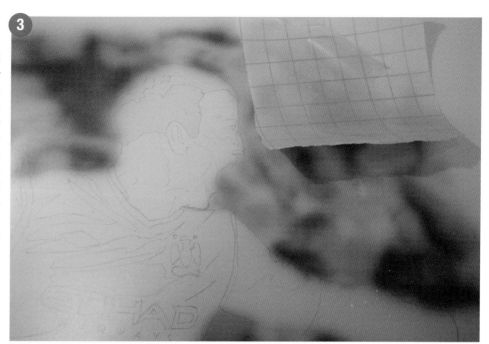

The entire picture is then wiped down with a tack cloth or clean dry tissue to remove dry overspray, then covered with a piece of matt frisket film. The focus of this picture is the face so most of the attention will be concentrated on this part. Portraiture is a specific art with very little room for error. To begin with, carefully cut out the main profile of the face. (In this example, this includes the neck, but you may choose either to include or exclude it, depending on what you are working on; every piece of work is different.) Do not discard the cut-out frisket as you will need it again later. Instead, place it onto a spare piece of left-over frisket backing.

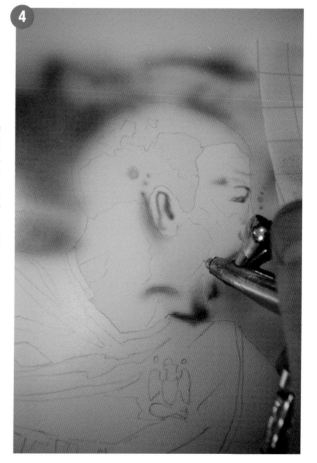

To help map out the main features and get a better understanding of where the light and shade falls, begin painting the shadows using transparent sepia or burnt umber. This can be regarded to an extent as an under-painting. This technique in various forms has been employed by portrait painters for centuries. In this example, the likelihood is that this painting will eventually be covered over with more and deeper colours. You may notice that the protective needle cap has been removed during this stage. This is simply to be able to get very close to the surface to begin building up the finest details, even at this stage. You may encounter a little spatter from time to time. You can counter this either by dropping your pressure to 20–30psi and/or thinning your paint to a watercolour consistency.

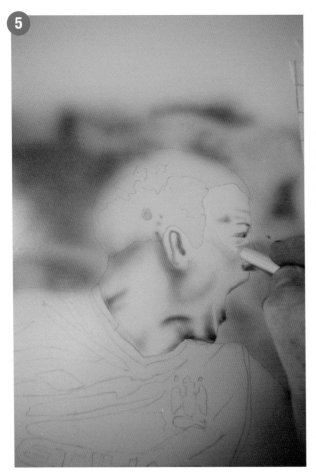

5

If you find that you have applied too much shading and everything is becoming too dark, don't despair as you have been using very small quantities of a transparent colour that has been thinned. You can reintroduce lighter areas by rubbing back to the board surface with an eraser pencil. You can also further define details such as muscle definition with the eraser pencil too. Painting by subtraction can happen at any stage in the painting process.

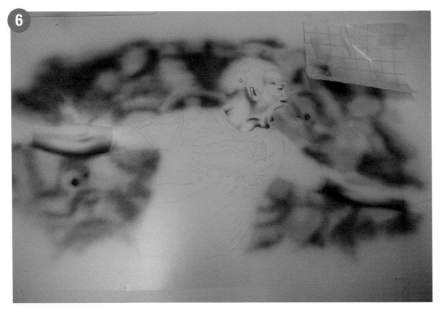

6

Once you have got the majority of the shading in place for the facial features, you can then turn your attention to other flesh areas, such as in this painting, the arms. It is useful to have some form of photographic reference to turn to, to help you determine where to place light and shade. The main considerations are usually the direction of the main light source, and the strength of the light, which will determine the depth of shadows. In this picture, the action took place outside on a bright, sunny day in May. The uppermost surfaces would be very light and the undersides of objects would have some colour without being completely black (an absence of light). As with the face, carefully cut out the skin sections of the body using a sharp knife and place the 'positive' sections of frisket onto some backing.

Now you can begin adding the main colours to your work. Starting with the lightest colours first, gradually build up colour into the exposed, white areas. Only when you get to your deepest skin tone colour will you begin reworking (if necessary) the tonally dark areas you initially worked on. Once that has been completed, work on the very lightest and very darkest areas can begin. In this photo, the positive mask for the face that was initially removed has been put back in place and the outline profile of the ear has been cut. Only part of the frisk has been peeled back to expose the ear and white is painted on the bottom edge.

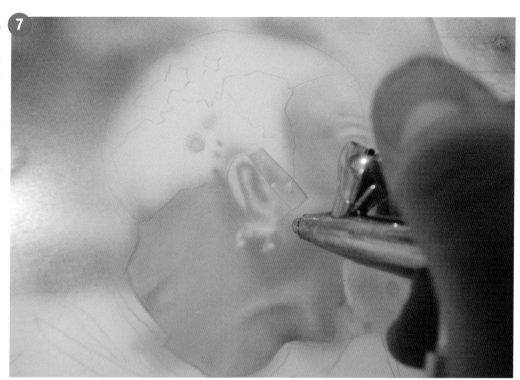

Once this has been completed, the positive frisket for the face is removed again and the resulting white edge to the lower ear can be seen. You can repeat this process all over the face for lighter and darker areas where a crisp line is needed. The cut frisket will give you this edge.

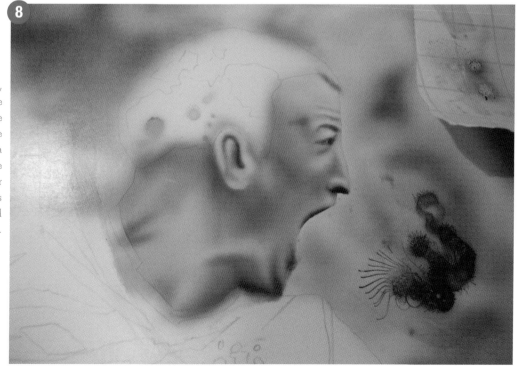

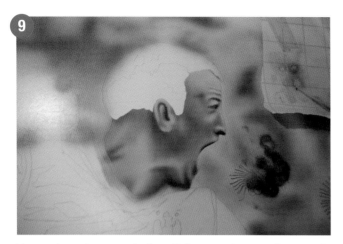

Now work can begin on the hair. To begin with, cut and remove the masking from the next area you want to paint.

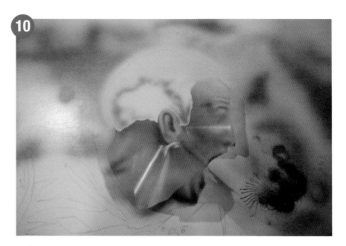

This process is called reverse masking: one piece of mask has been removed and the corresponding adjoining edge is put back in (the face). Notice that the piece has not been positioned completely flat, as only part of this masking is needed to create an edge. Most of the masking serves no other purpose than to protect the detail you have created in the face. As with the face, begin painting in the darkest areas as an under-painting.

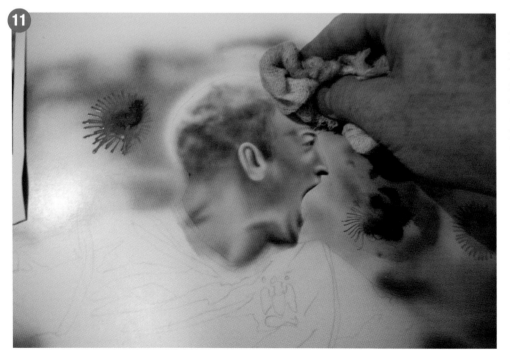

Begin working with your premixed opaque hair colours. In this picture, two have been mixed, painting the lighter of the two first. When you are happy to remove the mask on the face, begin airbrushing out any unwanted edges between face and hair, spraying at very close proximity to the surface. Very light (not white) highlights are added at the end to help balance the two areas (hair and face). Finally, when all the masking for these two areas has been removed, begin carefully wiping down with a tack cloth to remove the last traces of dusty overspray.

To add the finest of details to the hair, carefully scratch the surface to create individual hairs. Do not cut into the surface, but instead pull the blade sideways to create a scratch or scrape. Small lines of paint will be removed from the surface that will probably reveal the same colour as the starting surface colour of your board. If this proves too white or light, you can always lightly tint them afterwards with a transparent colour.

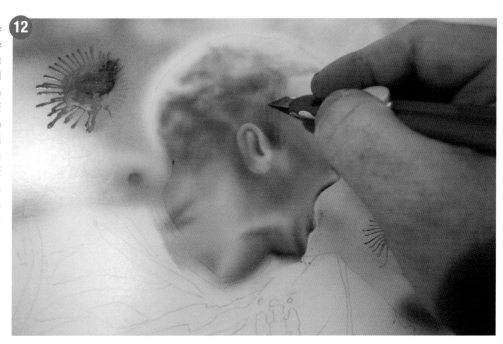

Now that the vast majority of the work on the face has been completed, this can be once again covered with either some new frisk, or if the original positive mask is showing no signs of unwanted paint build-up, you can reuse that.
The sponsor's logo on the jersey has been created using a combination of carefully cut frisket, and then some liquid latex applied with a silicone tipped brush to create the smaller of the two lines of text. This is applied directly onto the white board before any painting takes place. The lighter and then darker colours of the jersey are then applied.

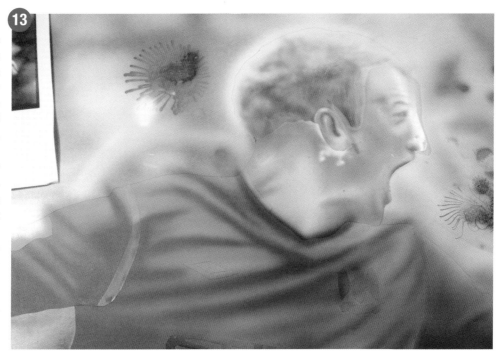

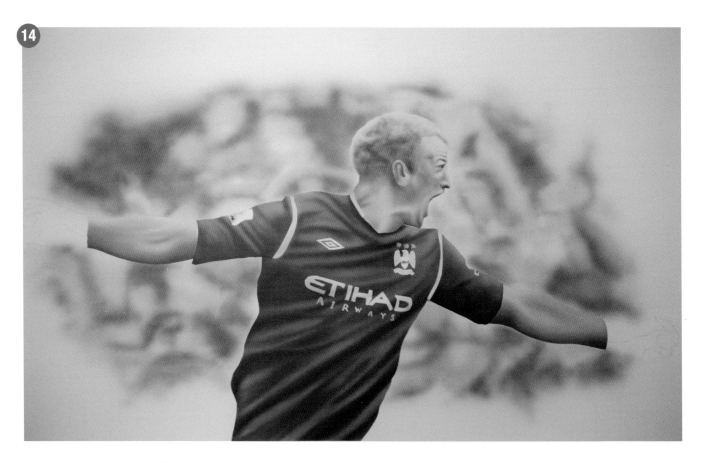

14

All the masking is removed. Using a little transparent grey, shadows are lightly painted over the logos to balance them out with the rest of the jersey. Transparent yellow is painted onto the blank areas of the board. You can choose to use masking or go in freehand if you're feeling brave. Only a thin wash of yellow is needed. Finally the goalkeeping gloves are airbrushed in then a period of time is spent 'nitpicking' and correcting any minor blemishes. It is important that the whole picture balances out correctly, so spend time freehand airbrushing or reworking areas with the aid of masking. In this picture, I felt the final image looked a little odd at the bottom left corner of the figure. A little artistic licence was employed in altering the profile shape to help balance out the main figure.

Finally, the finished image was sent away to be professionally photographed and printed, with explanatory text beneath added by the printer. What gives this image such great impact is the crisp foreground figure in perfect focus, combined with the blurred background. Using a combination of techniques such as masking and freehand will enable you to achieve this sort of effect in any composition.

Airbrush	Paint/Medium	Surface	Tools/Materials
H&S Evolution	Liquid acrylic ink	Schoellerhammer 4g	Frisket
0.2 nozzle size			Eraser pencil
H&S Infinity			Electric eraser
0.15mm nozzle size			Knife
30-40 PSI pressure			Pencil/graphite

TECHNICAL DATA

PROJECT 2:
AIRBRUSHING HANDS, TECHNICAL ILLUSTRATION

This project has been inspired by an iconic image by Escher entitled *Drawing Hands*. In this illustration, the overall image will have a colour tinted feel to it rather than trying to look like a photo. Also, airbrushes are placed in the hands instead of pencils. As with the previous project in this chapter, frisket film will be used as the main form of masking. The addition of this project in this chapter is to show you another way of approaching work; Painting a picture in 'black and white', then tinting with colour after. The feel of this image, although masked in the same way as the other picture in this chapter, will be very different.

Airbrushing Hands.

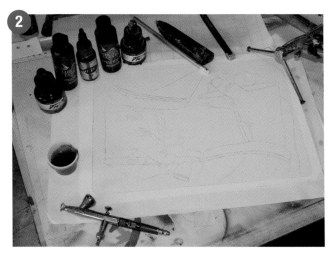

To get to this stage, a photo was taken of a hand holding an airbrush, then printed onto paper. The back of the photo was covered in graphite, placed on a surface ready for painting (Schoellershammer 4G card) and retraced. The resulting image was 'carbon copied' onto the surface.

As with previous projects in this book, a 'not black' has been separately mixed in a cup using a variety of brands and deep transparent colours. The whole surface of the picture has also been covered in frisket film ready to be cut.

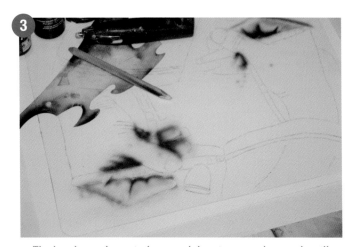

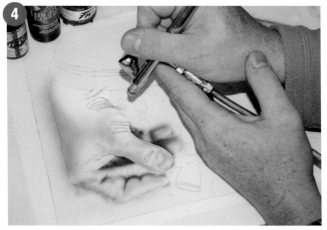

The hands are the main feature of the picture and, as such, will require quite a high degree of detail. Hands are notoriously difficult to paint as they have so much intricate detail that will challenge the most accomplished artist. Here, the frisket on the hands has been removed (retain the pieces on its backing) and a combination of stencil and freehand airbrushing of the shading and details commences.

In this photo you will notice the needle cap (crown) has been removed. This is because of the exceptionally close work freehand airbrushing in the fine creases in the skin.

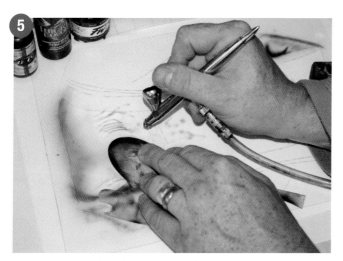

To create a little variety in the quality of edges, even on the smallest area of detail, alternative airbrushing methods are employed. Here, a basic French curve stencil is used.

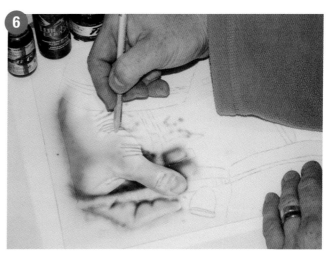

These details can then be worked again to give additional detail and clarity and help tie together by using an eraser pencil to bring back highlight areas that may have been lost through applying too much paint or through unwanted overspray in the freehand application.

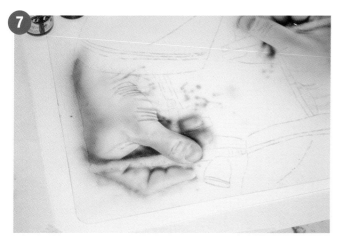

Just by using one colour alone, great tonal values and various masking and freehand methods put together have created a pleasing monochrome image.

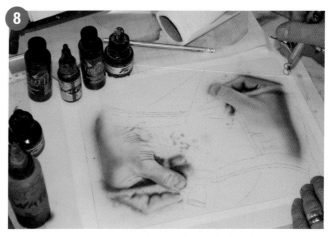

Now some colour can be used to 'tint' our black-and-white picture. It is standard practice to apply lighter colours first, followed by darker and darker colours when painting in opaque colours. In this case, however, transparent colours are being used, so the opposite is the norm: the darkest tones are painted first.

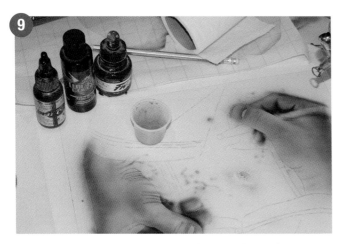

A lighter skin tone is relatively evenly sprayed over the entire exposed area, followed by some thin tint washes of transparent purple and scarlet to give the skin tones some additional colour impact.

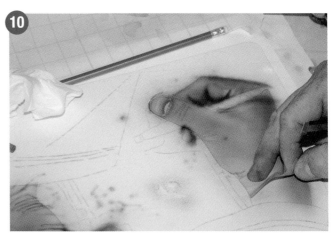

Once you are happy with the skin tones you have painted, reapply the masks for hands you saved earlier. Ensure that they are replaced in exactly the correct position.

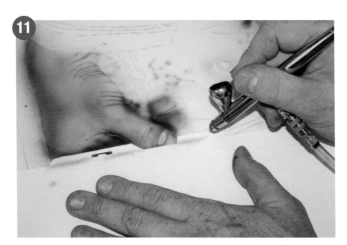

Cut and remove the frisket protecting the airbrushes on the picture. These can now also be airbrushed using the 'not black' colour. Refer regularly to your photographic reference to ensure that light, shade and reflections are in the correct places. Here, a straight-edged piece of paper is used to recreate a straight reflection running along the length of the airbrush.

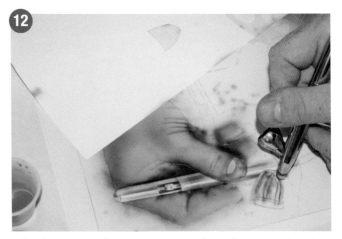

Combine your techniques such as freehand, loose stencil, frisket and subtraction of paint to create the correct tonal values in your picture.

Both hands holding their airbrushes are now almost complete. To retain a balance between the two hands, consider painting a little white in highlight areas of the skin. This will lighten what you have done, but used sparingly can help create a better contrast between the very darkest and lightest areas.

The sleeves of the objects are now de-masked ready for tinting. As this part of the painting is designed to look incomplete, only a light colour tint suggesting light, shade and material should be applied. To retain the softness of the sleeve material, detail is freehand airbrushed.

Any remaining masking is removed and the initial pencil lines that are no longer required but still visible are rubbed out.

A is for Airbrush

Chapter 10
Using computer-cut vinyl stencils

10

Computer-cut vinyl graphics have been with us for several decades, and it is now possible and cost-effective to create your own vinyl graphics using a home computer. This chapter will go some way towards explaining how this technology will benefit the airbrush user, and how to put these ideas into practice.

On the open market there are now a range of budget plotter cutters that are affordable for most households. The cost of a budget plotter cutter is roughly about the same cost as a low-end new computer. Usually, these plotter cutters come with their own software that can be installed onto any PC or Mac. These programmes are often quite simple, and with a little practice, you can produce vinyl lettering and graphics quite easily. One such affordable plotter cutter is Silhouette CAMEO™ by Graphtec. The Silhouette CAMEO™ connects to your computer, allowing you the freedom to cut all your fonts, or design shapes of your own with the included software. It will accept material up to 30cm width and has the capability of cutting not just vinyl but also paper and thin card. Often, the hardware will have the capability to work with other graphics software such as Techsoft, Microsoft Word, 2D Designer and Coreldraw.

Airbrush	Paint/Medium	Surface	Tools/Materials
Iwata Revolution CR	Liquid acrylic ink	H&S airbrush paper	Plotter cutter
0.5mm nozzle size			Paintmask vinyl
30-40 PSI pressure			Scrap paper
			Knife & masking tape
			Application tape

TECHNICAL DATA

The Graphtec Silhouette CAMEOTM.

TIP **MASKING**

You can never have enough masking when dealing with projects such as this. Always ensure that exposed areas of painted surface that should not have any other colour on are masked, especially when other colours are being sprayed.

LEFT: *A is for Airbrush*: airbrushed graphic using liquid acrylic and digitally cut mask by Fred Crellin.

Silhouette Studio was used to design the text for this project. This type of graphics package often comes included with the plotter cutter 'hardware'. They are designed to be quick and easy to use, with a little practice...

Your plotter cutter will then cut some material to the design you have produced. The material used in this project is called blue paint mask. It has very similar properties to that of frisket film and should be cut with its backing still attached. Once cut, a sheet of application tape (a low-tack tape with similar properties to masking tape, but available in roll sizes up to one metre wide) should be cut and applied over the top of your

Remove the paint mask and application tape together from the backing. Carefully place in the correct position on your surface to be painted. Here, H&S airbrush paper is being used. The mask and tape should be smoothed flat so no air bubbles or pockets of air are present under the surface. A simple way of achieving this is to rub your hand over from the centre to the outside all the way round.

Begin carefully removing the application tape from your paint mask. The function of the application tape was to ensure that all the cut pieces stayed in the correct place when it was removed from its backing. Now that has been achieved, it can be discarded. When removing, ensure none of the cut lettering pops out. If it does, carefully push back into place as you are pulling off the application tape.

Your cut paint mask should now be firmly attached to your surface ready for painting to begin. If you attempt your own design, you may choose to remove the inside (negative) parts of the lettering to expose areas for painting. However, in this project, these are being kept in place so the outside edge can be painted.

About seven coats of a premixed opaque aqua blue (using blue, yellow and white) are sprayed onto the exposed surface until all the white has completely disappeared. This is better known as the saturation point.

Some of the text is then covered over again. This may seem like unnecessary extra work as this lettering was already protected. The reason this has been done is to ensure no unwanted paint gets into the computer-cut lines. If you accidentally spill paint or apply too much wet paint into the main 'A' and wet overspray covers the smaller text, there is a chance that this paint may leak under the paint mask and cause a problem later on.

Another colour (created using red, white, blue and purple) is then sprayed from the top of the letter and blended into the pink to create a seamless colour fade from purple to pink.

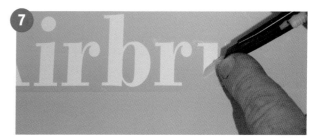

Now all the lettering can be carefully removed from the work. A craft knife is used to gently pull out each letter. What should remain is crisp, accurate, computer-cut text. In this work, the lettering is not intended to be used again. However, you may find it useful to carefully store the discarded lettering on the left-over paint mask backing. You never know, you may need it again to rectify any mistakes or errors later.

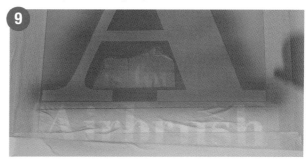

The letter 'A' can now be airbrushed with a graded tone of a pre-mixed deep rose pink colour (made using red, white and purple). It is vital that each coat is sprayed on dry. Any wet paint may leak under your crisp computer-cut edge, defeating the object of creating a clinically clean-cut painted edge.

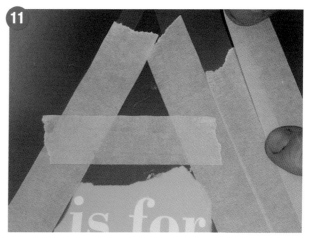

The next section of text is then masked up. Here, the letter 'A' just airbrushed is protected with ordinary masking tape. However, you can use application tape, the discarded paint mask or scrap paper (or any combination of these).

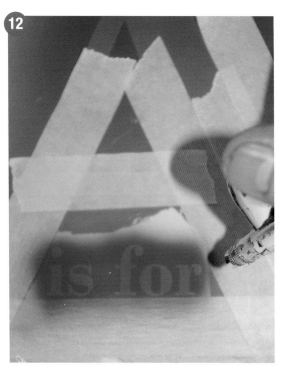

The text under the letter 'A' is then airbrushed with a flat tone of the pre-mixed purple. As this area is quite a small section, the text can be airbrushed from slightly closer range, but without going so close that the applied paint goes on streaky.

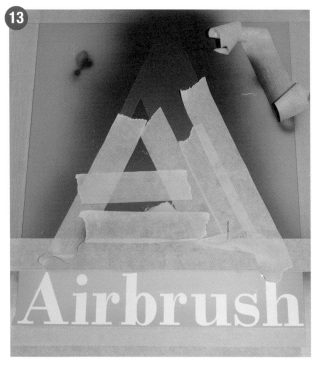

The small text is then covered over with masking tape and the word 'Airbrush' is revealed. This piece of text is going to have a strikingly simple effect added to it using all the three colours already used: it is going to be painted in a faux chrome effect.

Fold and tear a scrap piece of paper and line up the torn edge halfway up the text, protecting the top half. This edge is going to create the horizon line of the faux chrome.

Using purple, spray directly over the edge of the paper from fairly close (1cm). Build up a strong grade of colour that fades out towards the bottom of the text.

Remove the paper mask and repeat this process at the very top of the text.

Change your colour to the mixed blue and lightly spray a little colour above the central 'horizon' line.

Change your colour again to the pink and lightly spray the bottom half of the text below the horizon line.

Finally, remove all the masking from the work. Any corrections to the edges can be completed if necessary.

Chapter 11
Airbrushing a scale model, using fine line tape

<div style="text-align:right">11</div>

The key to any form of model making, just like airbrushing, is to be organized. Having a clear plan before you start will save you a lot of unnecessary repainting

and re-masking. In this chapter, the focus of attention is a re-liveried Red Arrow. This iconic British plane underwent a makeover in 2012, seen here emblazoned

in a graphical form of the Union flag, together with a take on the RAF target on the underside.

Airbrush	Paint/Medium	Surface	Tools/Materials
Iwata HP M1	Liquid acrylic ink	Plastic	3mm fine line tape
0.2mm nozzle size	Varnish/Lacquer		Liquid latex, Frisket
30-40 PSI pressure			Paintbrushes, trace paper
			Knife, masking tape
			Wet or dry sandpaper

TECHNICAL DATA

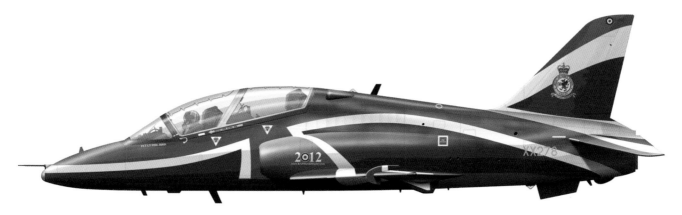

Re-liveried Red Arrow ©Andy Hay.

If you deviate from the plans as we are doing here, it is useful to have as much reference material to help you paint your model correctly. You can never have enough reference material! Here, an image by another artist is being used, together with a magazine with some useful photographic references.

LEFT: Re-liveried Red Arrow, model airbrushed by Fred Crellin.

Before you start painting, make sure you have all the parts and begin carefully reading any instructions that come with a model kit. With this model, there are a number of colours that need to be purchased or mixed. As this example is not strictly adhering to all the instructions, the colours have been hand mixed using a combination of automotive and liquid acrylic paints. You can, if you choose, use oil-based enamel paints. However, the drying time of these is considerably longer than that of most acrylics.

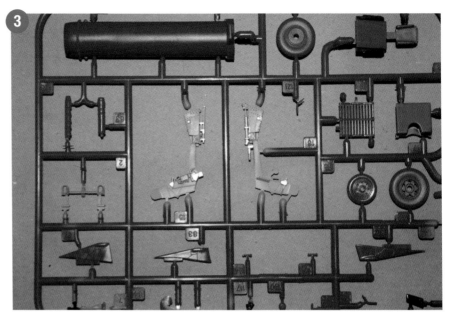

Not every piece will need airbrushing and sometimes it's just easier to use a paintbrush. However, as paint can be applied virtually dry to a surface, paint adhesion is a lot better and more even. Finer details needing a sharp edge can be added in after an airbrushed foundation coat has been applied.

TIP **PAINT ADHESION**

Paint will never stick properly to a shiny surface. Ensure surfaces are properly prepared by using either an adhesion promoter or key the surface with fine sandpaper such as 800-grit wet or dry sandpaper. The microscopic scratches in the surface give the paint something to stick to.

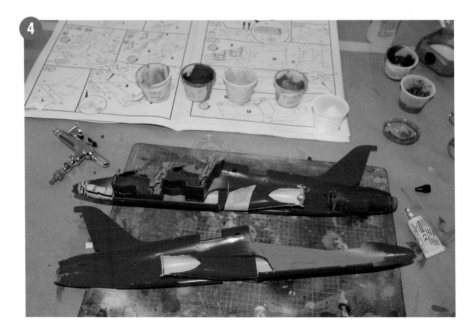

Once all the internal parts have been painted, construction can begin. As most of these parts will never physically be touched again, there is little to worry about paint coming off or being worn off the surface. Also, the instructions supplied have been carefully followed.

The surface of a model, especially where pieces are joined together, will need extra preparation. To eliminate unsightly joins, firstly fettle the uneven surfaces by scraping a craft knife over the join.

Then gently rub some 800 grit wet or dry sandpaper over the surface to finish smoothing it off. This will not only remove any traces of the join, it will also help paint adhere better to the surface.

Begin carefully masking up any areas that you do not want to get paint over. Here, ordinary 1in masking tape is placed and cut to shape around the cockpit of the aircraft.

The clear 'glass' areas that have been fitted to the main body of the aircraft do not need to be painted. The easiest way to mask these up is with a few drops of liquid latex, applied with a silicone-tipped brush.

Using a pre-mixed red to match the colour of the plastic kit, the seams are all airbrushed with three or four coats. To speed up the drying process you can apply some gentle heat with either a hairdryer or heat gun on a low setting. The main body is then placed off the surface.

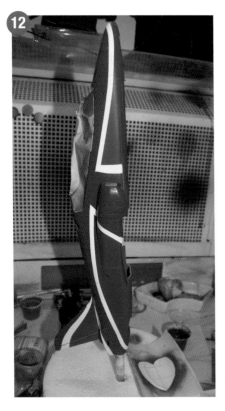

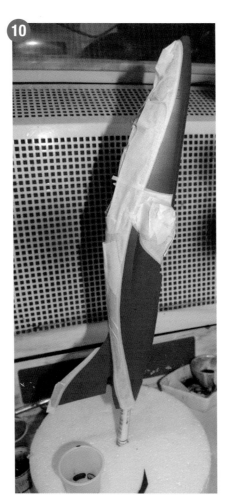

The red areas of the main body that need protecting are now covered with a combination of masking tape and fine line tape. The 3mm fine line tape can be curved around the contours of the body and will ensure a crisp edge (superior to ordinary masking tape) between the three main colours. Anything that is to be painted either blue or white is left exposed and painted with three or four coats of white.

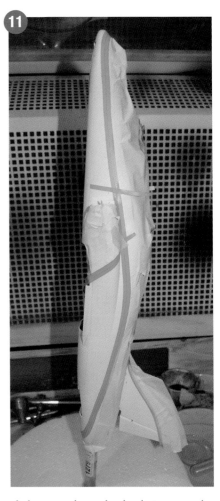

A dummy cake made of polystyrene and a plastic tube is used to hold the body vertically, ready for masking and painting. Here, an automotive basecoat white acrylic has been used. Fine line tape is then applied over the white where the white stripes of the design are present. Apply the tape carefully, ensuring the tape is in the correct position. Refer to your reference pictures regularly for guidance.

The exposed areas of white are now covered in four or five light coats of pre-mixed blue. After ensuring the colour has been applied evenly, dry the paint with some gentle heat, and then carefully remove the masking, leaving only the masking in the cockpit on the body. This should only be removed at the very end of the project, as handling may damage this delicate paintwork. The main body can now have any decals applied.

Work on the wings can now begin. The same process is repeated for the tops of the wings, beginning with the 3mm fine line tape protecting areas that will remain red.

The exposed areas are airbrushed with three or four coats of white. It is essential that you paint each coat sparingly and that the paint hits the surface virtually dry. Any wet paint that is applied may leak under the mask resulting in an poor quality edge. Once dry, the white areas are then masked over with 3mm tape and four or five coats of blue are then evenly applied to the resulting exposed areas.

For the underside of the wings, an exact curve for the left and right wings needs to be achieved. To match both sides exactly, use some fine line tape on one side and accurately recreate the curve needed.

Then, using a small piece of tracing paper, trace over the curve you have created on the one wing. This can now be cut and be used as a template for the other side. To create a mirror image, flip your tracing paper upside-down.

A mirror image curve can be created using more fine line tape.

To create the heart in the centre of the target on the underside of the aircraft, the heart and centre circle are drawn onto some frisket film. By chance, the correct size of the circle happens to be the same size as the inside of a roll of masking tape.

TIP

MASKING MULTIPLE LAYERS

When masking multiple layers, try to organize your planning so you do not have to remove and re-apply masking to an edge. The method employed here involves only applying masking over previously painted surfaces. Masking is only removed at the end of the job. Remember, masking takes time, whereas painting can be relatively quick.

The heart can now be airbrushed onto the white. As this is the first time red has been applied onto white, it is important to bury the white under several coats of red. Here, seven coats have been applied. Do not throw your frisket film away until the end of the project as it will be needed again to paint the wheel housing flaps that are added later.

Finally, using a very small brush, paint in the unique details that adorn the aircraft. Masking tape is used to help size and locate the precise position of the text.

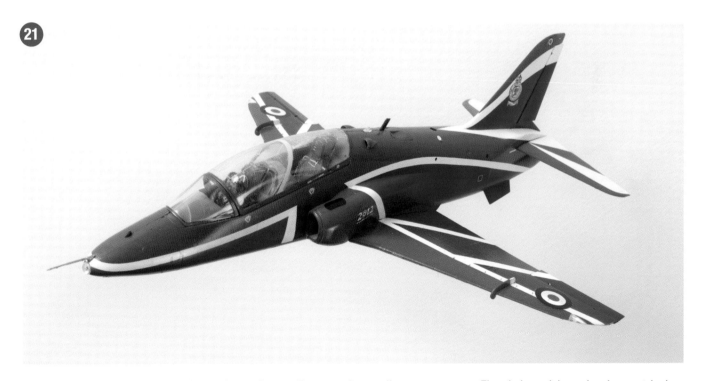

Decals can then be applied to the finished aircraft, as well as any other small component parts. The whole model can then be varnished or lacquered. Make sure the masking in the cockpit is still in place, as you will not want to varnish/lacquer these details. You can use any number of varnishes or lacquers on your model. Be aware that some lacquers may turn some white paints slightly yellow, so it is good practice to test your chosen product on a scrap piece first.

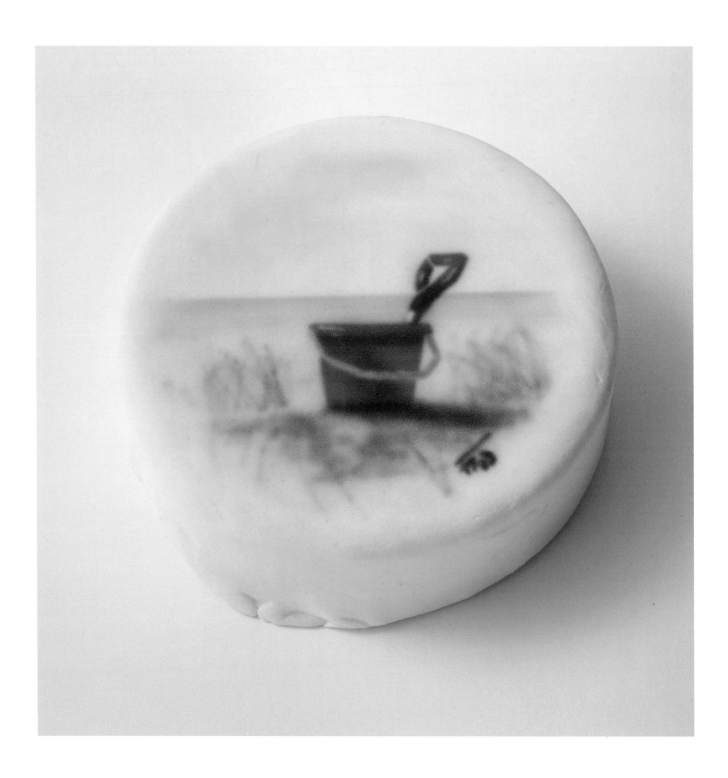

Chapter 12
Airbrushing cakes using multi-layered stencils 12

The technique of using a multi-stage stencil is not new or ground-breaking. In fact, the technique is taken straight from screen printing technology, but adapted to suit airbrushing. Each colour component is cut separately, then lined up and airbrushed in turn.

The first exercise will use a simple three-part process, combined with a little freehand and other simple airbrushing to give the desired overall image – in this case a child's bucket and spade. As you will be using food colouring ultimately designed to be consumed, it is essential that your airbrush is clinically clean before you start. You do not want to be running food colouring through an airbrush that has recently used solvent-based car paint! It would be wise to completely strip an airbrush and clean every part with a cleaner such as isopropyl alcohol.

Airbrush	Paint/Medium	Surface	Tools/Materials
Iwata HP M1	Liquid food dyes	White icing sugar	Plain paper
0.2mm nozzle size	Food paste dye		Paint brush
15-20 PSI pressure			Pallette
			Knife
			Pencil

TECHNICAL DATA

To create your own stencil, perhaps consider tracing an image onto tracing paper, separating out all the individual components. In this example, a design was carefully drawn onto some plain paper, then carefully cut out. Do not forget that any 'floating' areas need to be attached to the main body. Here, the inner part of the handle has been attached using what are referred to as 'bridges'. These areas will leave a gap and can be airbrushed out later.

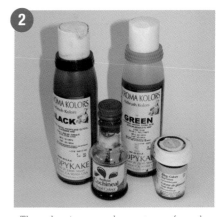

The colouring you choose to use for cake decorating depends on what is readily available. Here, a combination of ready-to-airbrush food colourants by Kopykake, liquid food colour by Dr Oetker and concentrated food colourant by Wilton have been used. If you use the concentrated colours, you will need to dilute these with a little water to the correct viscosity before starting. As these are food dyes, you will only need a low pressure (15–20psi) to undertake this work.

LEFT: *Bucket and Spade* on icing sugar by Fred Crellin.

If possible, position your cake on a turntable, so that it can be rotated at any point to gain better access. As your surface is so fragile, you want to avoid touching it all the time, especially as the food dye can transfer easily from your fingers onto the white icing.

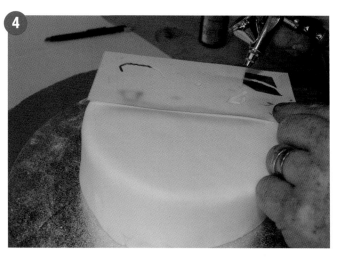

To begin the picture, start by using blue to create the horizon. A straight edge of paper will do the job. A little freehand blue for the sky will also enhance your image.

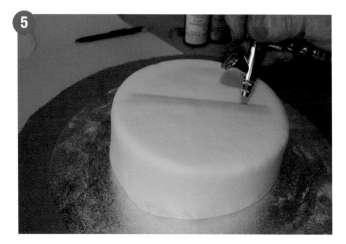

Change your colour to yellow for the sand and gently spray some yellow freehand over the 'beach' area.

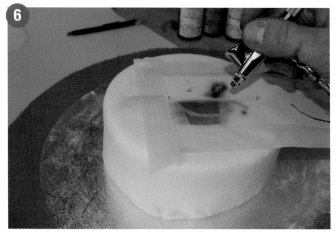

Place your template on the cake in the correct position. Here, some masking tape has been used, firstly to increase the masking area in order to protect the cake, and secondly to help give the paper a chance of adhering ever so slightly to the icing. Some red can now be applied in the exposed areas of the bucket and the spade handle.

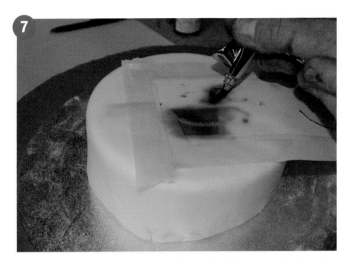

Changing your colour back to blue, airbrush in some shadowed areas of the bucket and handle. Try to imagine from which direction your light source is coming and have shadows on the opposite side to the light source.

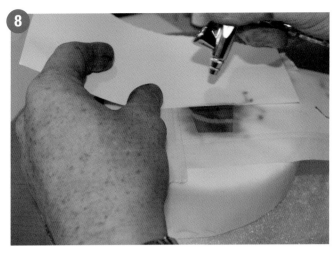

Using a straight-cut edge, airbrush in the rim of the bucket, using blue colouring. Here, a double layer of templates is employed to give the desired effect.

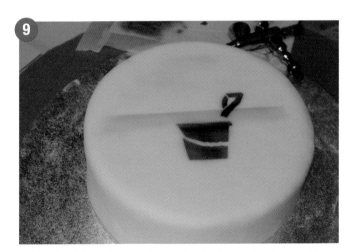

You should now have an image that looks a little like this. The bucket itself looks very unnatural as the edges are the same all the way around. This can be altered later.

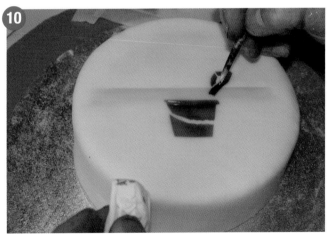

Intricate details can now be added to the bucket and handle. It would be more accurate here to describe this as having colour removed to give the detail. Using a fine paint brush or similar tool, carefully wet the tip with water and apply it to the area you want to be highlighted. Then, very quickly 'blot' this area with a clean, dry piece of tissue, which will soak up the excess moisture to leave clean, white icing. These areas will show where the highlights on the bucket and handle are.

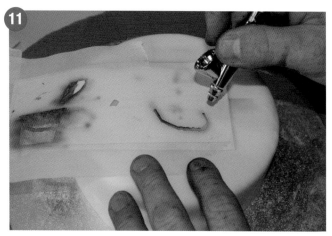

Replace your template so the handle of the bucket is in the correct position. Using a mixture of yellow with a tiny amount of red (or use orange), evenly airbrush in the whole of this area.

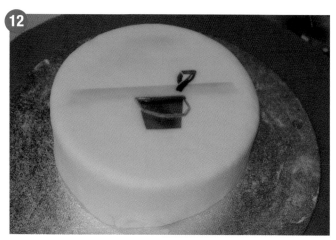

You can add a little shadowing or detail to the handle if you wish, while the mask is in the correct place. Here, a little red has been applied to the flat tone of colour in the handle.

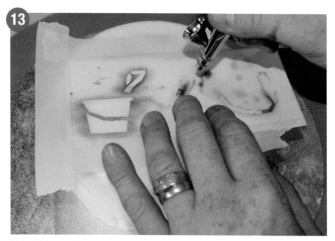

Now the spade handle is positioned correctly and sprayed in using black ...

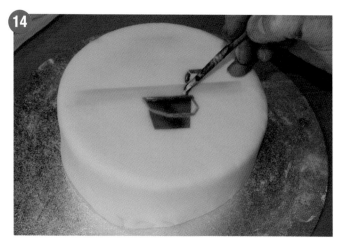

...and a highlight edge is added using the same technique as before with water and tissue.

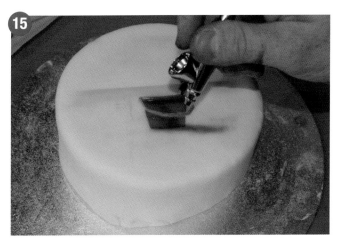

15 Continuing with the black, airbrush in some shadows falling from the bucket onto the sand.

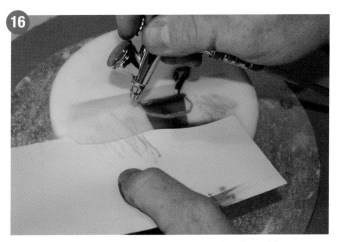

16 Change your colour to green in your airbrush, and begin airbrushing in some fine strands of grass. Begin at the root and finish your movement at the tip. Here, a cut piece of 'wavy' masking has been created to form an edge where the sand undulates.

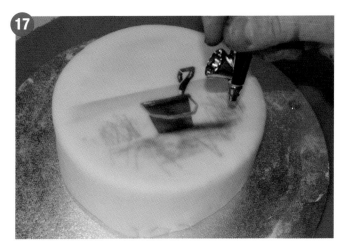

17 Finally, add a drop of red to your green mixture to create a brown colour and add some colour variation to the sand in the foreground. Also consider softening the bottom edge of the bucket where it meets the sand. By airbrushing this, it will make your stencilled image look more natural and realistic as you will have used different quality edges.

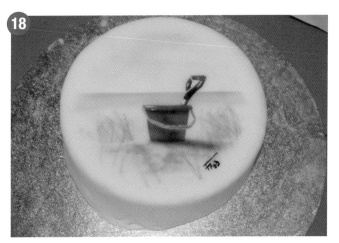

18 Make any necessary corrections and finish by signing your work with either a paintbrush or airbrush. If you intend using the template more than just a few times, consider creating one using the same method shown, but using acetate instead of plain paper, as this material can be washed and re-used over and over again.

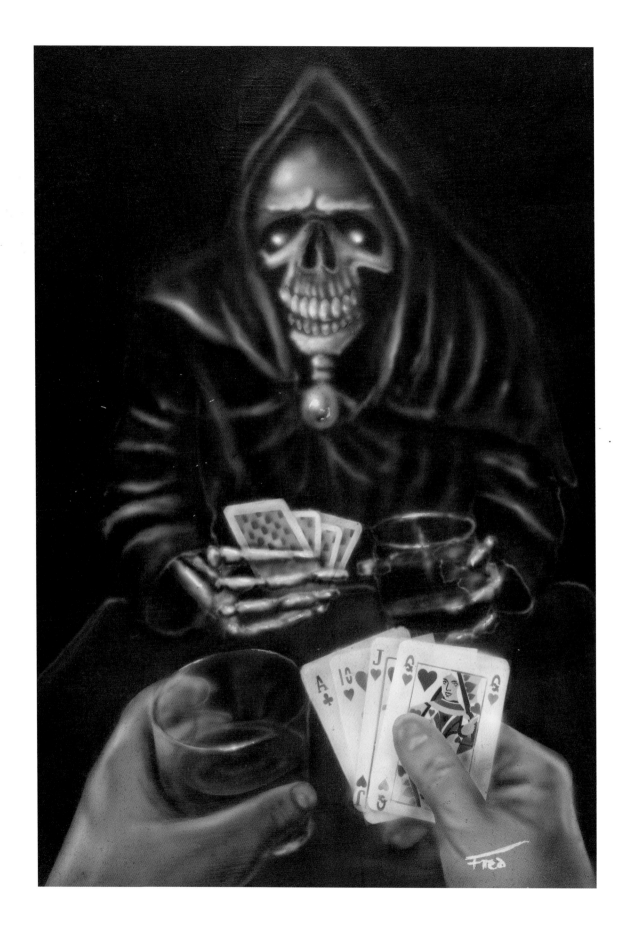

Chapter 13
Dealing with Death: Using manufactured stencils 13

Airbrush	Paint/Medium	Surface	Tools/Materials
Iwata Revolution CR	Liquid acrylic ink	Hardboard	Knife, panel wipe
0.5mm nozzle size			Plain paper, tack cloth
H&S Colani			Pencil, pastel, masking tape
0.8mm nozzle size			Whole deck of 54 stencil
30 PSI pressure			'Frontal' skullmaster stencil
			French curve stencil

There are currently thousands upon thousands of different airbrush stencils available to purchase on the open market. Many professional airbrush artists have gone on to design and manufacture their own designs. I can count myself amongst that group: one of my recent designs is used in this exercise.

> **TIP**
>
> **HOW TO USE MANUFACTURED STENCILS EFFECTIVELY**
>
> The most effective way of using a manufactured stencil is to disguise the fact you have used a stencil at all. Combine your stencil work where possible with other forms of airbrushing such a freehand techniques to vary the quality of edges in your work.

The stencils being primarily used in this exercise are 'The Frontal' by Craig Fraser (an Artool® stencil), one of many skull designs by this artist. The other is one designed and developed by myself through Artimagination, called 'The whole deck of 54' – a stencil designed to help you produce the entire deck of cards, including jokers, in actual playing card size. Other stencils, such as a French curve and ellipse stencils (by Artimagination), have also been used in this piece.

LEFT: *Dealing with Death*: acrylic onto hardboard by Fred Crellin, approximately 30cm x 40cm.

1

To begin with, a piece of primed hardboard is painted black using a Colani airbrush fitted with a 0.8mm nozzle, using Createx Autoair Base Coat Sealer (dark).

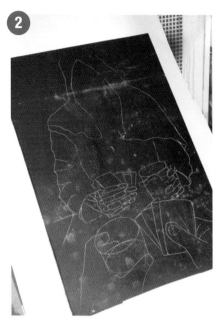

2

The image is traced on using pastel through a photocopied sheet of paper with a prepared photo reference on it.

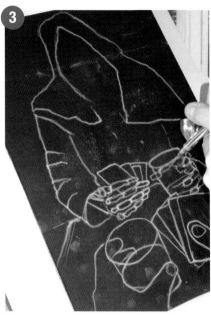

3

The pastel line work is then freehand airbrushed over with white acrylic using an airbrush fitted with a 0.5mm nozzle.

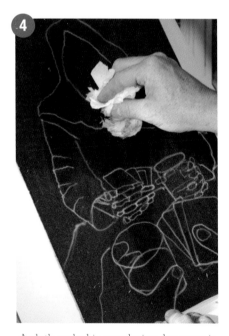

4

A cloth soaked in panel wipe degreaser is then used to wipe over the entire area, cleaning off any traces of the pastel work. Only the freehand airbrushing should be left.

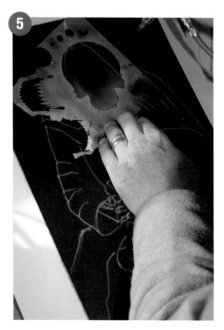

5

Now the first stencil can be used. Often, stencils will be made up of positive and corresponding negative images. Here, the negative outline of the skull profile is lightly airbrushed in white.

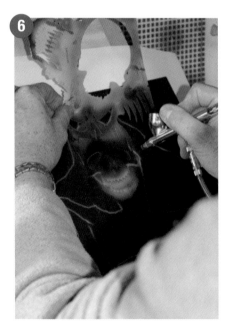

6

The positive part of the skull is then placed over in the desired position to create the eye sockets and nasal cavity. The top edges of the upper teeth are also lightly airbrushed in using black.

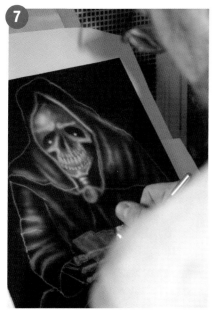

7

Highlighted areas of the skull and other features such as some skeletal fingers are also airbrushed in freehand.

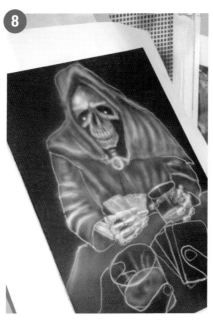

8

The cloak also gets some attention. Highlights in the folds of the cloth are 'roughed' in.

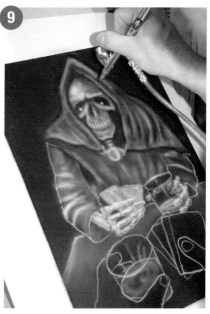

9

Using black again, the profile of the cloak is altered and additional shading is airbrushed in freehand.

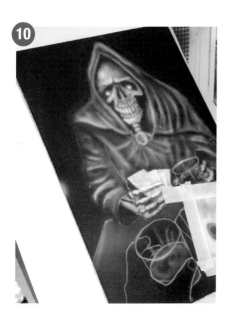

10

Masking tape is used to create the straight edges of the playing cards. White paint is sprayed into the required area.

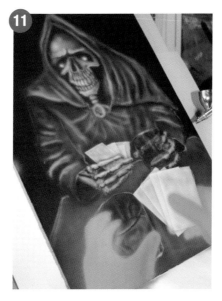

11

An opaque, flat skin tone is added for the foundation colour of the hands and transparent yellow is used to tint the skeletal bones.

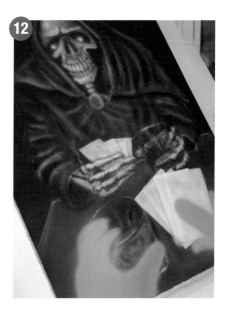

12

Transparent purple and transparent green are sprayed freehand onto the cloak and table top respectively. The deep green and purple will give the picture a deep eeriness.

A middle tone for the hands is freehand airbrushed in. Adding more varying colours to skin tone will make flesh look more realistic.

When approaching a piece like this, always expect a degree of correction/repair work. Here, the edges of the cards have been re-masked and repainted white. Ideally, try to avoid doing this too often as work can start to look untidy.

The detailing on the playing cards can begin in earnest. The card stencil has been designed as a multi-layered stencil. Each colour is correctly laid over using the prescribed section of stencil. Here, the outside edge of a picture card is being airbrushed in using black.

Continuing with the black, airbrush in from close range using a very small amount of paint. As this is a very finely detailed part of the stencil, it should almost be treated as if you were attempting to achieve the detail freehand.

Note that on either side of the queen there are two small crosses. These will help you line up each part of the stencil into the correct position. As you do not actually want the crosses in the final image, two small pieces of masking tape are temporarily placed over where the crosses will be located. The template is placed in the correct position and the crosses airbrushed onto the masking tape. Here, the stencil is being used so the next colour (red) can be airbrushed in exactly the correct position.

Then the next colour (yellow) can be airbrushed. As each picture playing card has a mirror image, the stencil is replaced upside-down accordingly, so the crosses line up.

19

The queen of hearts is now almost complete. Fine tuning and corrections can be completed using any combination of techniques.

20

The remaining playing cards are completed in the same manner.

21

The foreground hand can now be sharpened up using a French curve stencil. Black is sprayed over the edge onto the table top. This will give also give a shadow on the table.

22

Death's playing cards are individually masked up around the edge and a non-slip mat is used to create a pattern on the back of each card.

23

Finally, the glass is sharpened up using a French curve, and a paintbrush is used to add in the final highlights.

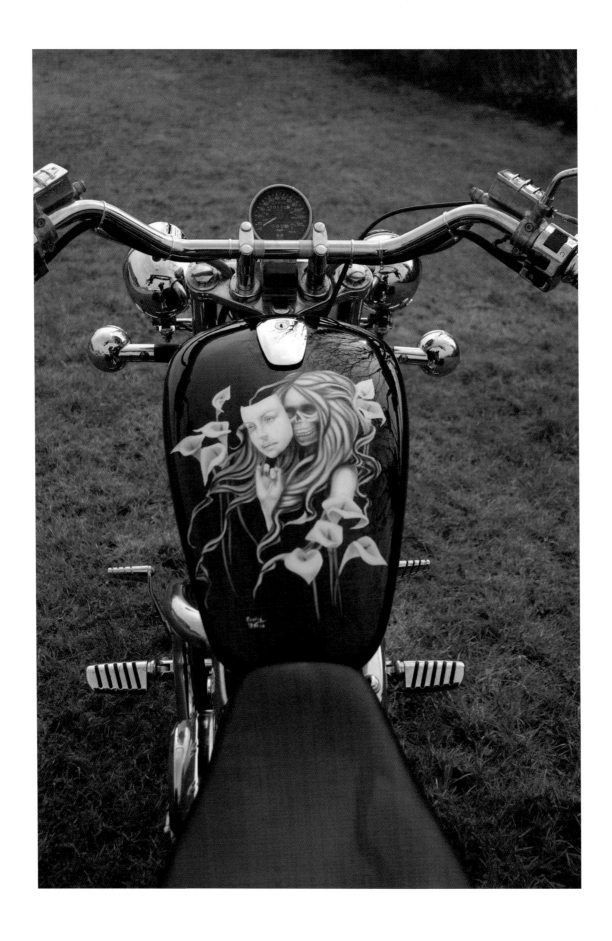

Chapter 14
Custom painting on metal and wood objects

14

PROJECT 1:
CHRISSIE'S TRIKE - CUSTOM PAINTING USING FRISKET FILM

Custom painting onto vehicles is one of the main areas of industry that airbrushing is immediately identified with. Today, most of the airbrush industry as a whole is dedicated to custom painting onto vehicles. Airbrushing in this context is no more than a more subtle and precise form of paint spraying, where artwork, graphics and colour effects can be achieved with relative speed and ease, but to great effect. In this exercise you will see that in reality, there is very little difference between custom painting and technical illustration. The only key differences are the initial preparation and the final finish given to the work. The main point to remember, however, is that on this occasion the surface is non-porous and should be treated with a great deal of respect. Unlike airbrush art board which is a porous surface that can be scratched, scored and rubbed with vigour, being too aggressive with a non-

porous surface could ultimately lead to going through the primed, prepared surface down to the sub-structure (metal or plastic) which could in turn lead to problems further down the line.

This project involves painting onto a petrol tank for a trike. The surface was stripped, primed and base coated in black before being given a couple of coats of two-pack lacquer. As this book is primarily an airbrush book and not a custom painting book, this chapter will not go into too much detail about surface preparation and lacquering, or lacquer application and types of lacquer. Although custom painting is very similar to airbrushing, it really is another animal: tabby cats and tigers, if you like. The best advice to the new airbrusher is to get a repair bodyshop to do the lacquering for you. The initial cost implications to kit yourself out to do lacquering with two-pack lacquers can be significant. If you have enough work to see you through a couple of months, then it may be worth investing in some extra equipment; for the occasional hobbyist, though, best results will only

be achieved with the correct equipment to enable you to produce quality work in a safe environment. Lacquers can be very dangerous and unless you are correctly equipped, health and safety implications may come back and bite you.

The tank in this exercise had been lacquered and was given a few days to cure. Before any artwork could be put onto the tank, further preparation was required. As a general rule, if the surface is non-porous, paint will not (usually) stick to it if it is shiny.

When attempting artwork on a surface such as a motorcycle or trike, remember that the surface area you will be working on will be quite small but still demand the finest of details. Unlike trucks and other large objects such as fairground rides (which tend to have as much detail but in a less concentrated area), this type of artwork will test your abilities with an airbrush to the maximum. You will have to achieve fine detail in small areas; any errors are likely to stand out as there is nowhere for them to hide.

Airbrush	Paint/Medium	Surface	Tools/Materials
H&S Infinity	Liquid acrylic ink	Metal petrol tank	Knife, panel wipe
0.15mm nozzle size			Plain paper, tack cloth
25-35 PSI pressure			Pencil, masking tape
			Scotchbrite pad
			Ellipse stencil, eraser pencil
			French curve stencil
			Frisket film, marker pen

TECHNICAL DATA

LEFT: *Chrissie's Trike*: custom painted trike by Fred Crellin.

Simple but effective artwork on a
motorcycle tail unit.

Artwork on a Harley Davidson V-rod.

TIP

TAKE EXTRA CARE WITH SMALL-SCALE PROJECTS

When undertaking detailed work in a concentrated area, there is little room for error. To avoid costly mistakes, ensure masking is thorough and that you have a plan of action in place that notes what order you will approach your work. This will save you time and effort in the long term.

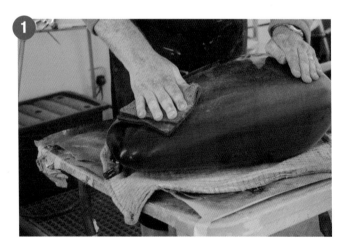

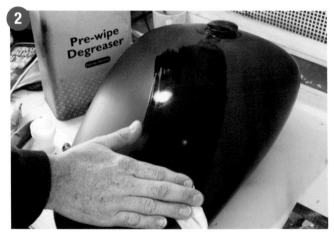

This job requires the surface to be correctly prepared to encourage adhesion of any subsequent paint. In this piece, the surface has been prepared by rubbing a fine scouring pad such as Scotchbrite over the entire surface area. This creates lots of tiny little scratches into the surface that new paint will stick to. You can use wet or dry sandpaper, but avoid anything coarser than 800 grit or finer than 1500 grit. An ideal grade when applying artwork to your surface is 1200-grit wet or dry sandpaper.

Once the surface has been scuffed, it needs to be cleaned using a solvent based degreaser. This removes unwanted dust created from the sanding/scuffing and finger marks from touching the surface.

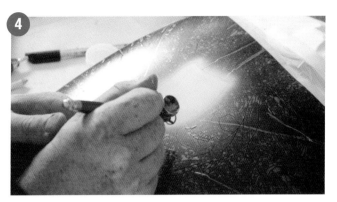

Now we are ready to begin producing the artwork for this tank. In this piece, as sharp edges are required, the obvious choice is frisket film. You could, as an alternative use application tape which is perhaps cheaper. However, application tape does not have the same re-sticking qualities that frisket offers. Frisket film can be re-applied up to half a dozen times before the stick wears out and it becomes unusable. You can also see what is going on underneath frisket film, which can make tracing images easier. This piece of frisket film has already had the image traced onto it using a fine, permanent black marker. However, although a black marker pen has been used in this exercise, this is not the best choice as we will be working on a black surface. A better choice would be a white chinagraph pencil. Note in this photograph how the film has been applied to the surface to make it lie flat to the surface.

Carefully cut out the first piece using a sharp blade. When cutting, avoid cutting into the surface you want to paint. The simplest way of doing this is to 'feel' the blade cutting through different surfaces. Frisket film will feel different to lacquer and metal as you cut, and you should get used to knowing what feels correct. This first area will have a lot of attention paid to it as it is one of the key focal points to the artwork. An opaque base colour is applied flat to create a foundation for more detail later. The colour that has been applied here is a warm grey colour primarily made up of black, white and sepia.

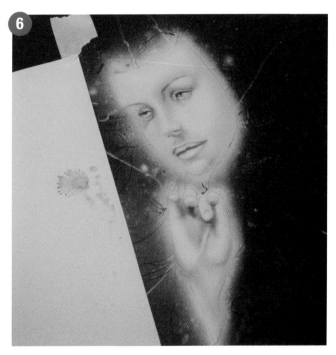

Using transparent sepia that has been very slightly diluted with water and applied with a 0.15mm nozzle at 25psi, the task of creating the fine detail for the face can begin. In this example, a range of tools and materials were used such a ellipse, circle and French curve templates, as well as specifically cut frisket and paper pieces. Great attention to details such as the light, shade and most importantly the shape and position of all the key features (eyes, nose and mouth) should be observed.

Repeat the process for the hand, ensuring that a contrast is maintained between light and dark tonal values. Do not become overly concerned if you think you have applied too much of the transparent colour, as the next stage involves removing colour.

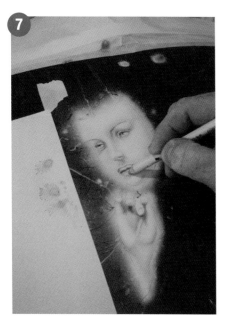

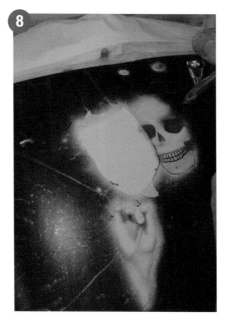

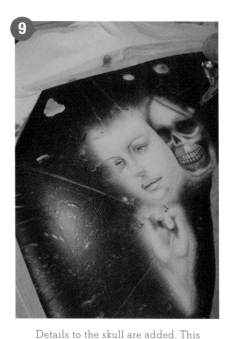

Now you can begin putting in the finest of details and even texture by carefully rubbing away small areas of the laid transparent colour, revealing the base colour beneath. As you will be working on a non porous surface, it is essential that you do not become too aggressive when removing paint. As a sensible precaution, use the soft (pink) end of your eraser pencil.

Work can now begin on the accompanying skull. However, you must carefully protect the work you have completed. In this example, a cut piece of paper has been used and held in place with masking tape. Similar techniques and processes are used in creating this component of the picture as previously used. However, an added process is shown in this part to give you a better understanding of how to put the details in the correct position. A paper template was used to put in the main features (eyes, nose and teeth), and sprayed with a darker mixture (sepia and umber) of transparent paint.

Details to the skull are added. This includes all the light and dark areas and any areas with greater detail in. When this area has been completed, remove the paper masking to check the contrast in light and shade between the two parts now painted. The delicate face should be much lighter than the menacing skull. This photo shows that this has been achieved. Another reason for using paper as a mask to protect the face is that you can easily lift this mask to see what progress you have made in getting the correct contrast.

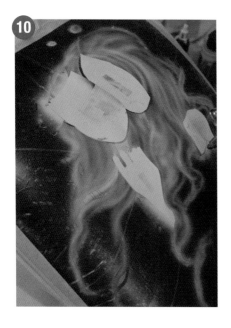

The completed areas are once again covered with a paper protection. To hold them in place, a small square is first cut in each of them, and then a piece of masking tape placed over the square hole. This exposed tape is what holds the paper mask in place. The other advantage of using paper as a mask in this instance is that the edge will be softer. A tiny amount of paint can be allowed to leak under the paper to give a more fluid and less harsh join from one section of artwork to the next. This can be achieved by spraying at an angle where paint may leak under. As long as no wet paint is allowed to collect on the mask, this method of creating a semi-hard-semi-soft is a useful tool in the techniques box. As this section is being primarily freehand airbrushed with whiter paint to get the flow of the hair, this technique works well for this section of the artwork.

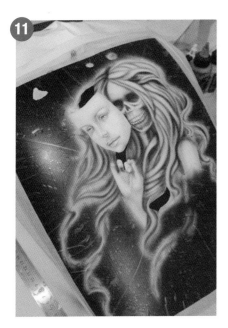

Darker tones for the hair are then added in the gaps left by the absence of white. Use of a French curve came in very handy to produce and complete this section in a short period of time.

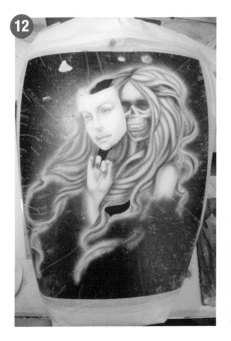

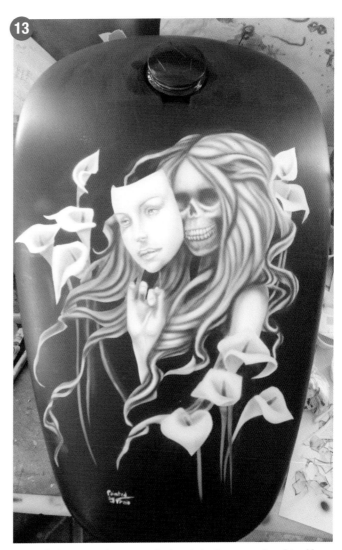

The whole area is then re-masked and the flowers painted in. Note that only a small splash of colour, a muted pink for the stamens of the flowers, is present in this composition. The artwork is checked again, signed and then lacquered and polished ready to be fitted onto the trike.

The frisket that is currently attached to the artwork is removed entirely, making sure no stray bits are left. If you are unsure whether you have been successful in removing all the masking, try shutting your eyes and gently rub your fingers over the whole painted surface. Any raised masking areas will soon be detected by your touch and you can carefully remove them by either picking off with a fingernail or even more carefully with a scalpel.

PROJECT 2:
CUSTOM PAINTING A VIOLIN

In this final project, many of the techniques demonstrated earlier in this book are used all together in one composition. Due to the delicate nature of the wooden surface, it will prove very difficult to cut directly on the surface without causing some damage. With extreme caution it could be done, but the risks are too great for such a valuable, fragile object. Instead, a series of loose masks will be used, together with other template techniques and use of liquid latex and tape. This way, you will be able to see how seamlessly a range of techniques can be used together in one project.

Airbrush	Paint/Medium	Surface	Liquid latex
H&S Infinity	Liquid acrylic ink	Wooden violin	Knife, panel wipe
0.15mm nozzle size			Tracing paper, tack cloth
Hansa 381			Pencil, masking tape
0.3mm nozzle size	2 Pack acrylic lacquer		Scotchbrite pad
25-35 PSI pressure			Dragon skin stencil, lace
Upol spot repair gun		**Tools/Materials**	French curve stencil
1mm nozzle/12PSI		Organic leaves	Frisket film, marker pen
1mm nozzle/12PSI		Tissue	Paintbrushes
		1200 Wet or Dry	

TECHNICAL DATA

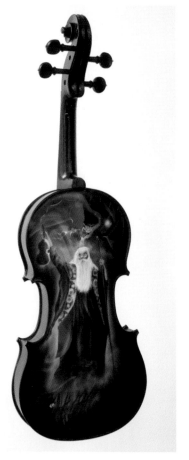

Merlin violin: liquid acrylic paint onto wooden violin body, courtesy of Merlin Electric Violins. Photo by Colin Mills.

Firstly, the front of the violin is carefully taped using 1mm fine line tape. This plastic tape will give an exceptionally crisp-edged line. The remaining inside area is then taped up using masking tape. The whole violin is then carefully wiped down with a solvent de-greaser to ensure there are no greasy finger marks on the wooden surface.

The whole violin is then sprayed with a small spot repair spray gun (1mm nozzle) at 12psi. The reason this is sprayed at such a low pressure has to do with the type of spraying equipment used. The spray gun is an HVLP (high volume, low pressure) device, where a larger quantity of air is emitted at a lower pressure. An airbrush on the other hand works on a different principle. It uses higher pressure but at a lower volume. This is why an airbrush will take longer to drain a compressed air tank than a spray gun. The paint used is water-based black sealer, similar to a primer.

Once the black has been given time to dry and cure, it is then gently sanded using 1200-grit wet or dry sandpaper. However, this process is done completely dry as using water would simply strip off the applied black paint. This light sanding takes away any roughness to the black, leaving a very smooth, porous surface.

To ensure no loose paint is present that would spoil the work, the surface is then finally wiped over with a tack cloth.

When the surface was sanded, some of the edges had some of the paint removed and will need some minor rectifying. Here, a little more black is applied over these edges with an airbrush.

Next, the artwork begins. Here, an image of Merlin has been drawn onto some tracing paper. The whole image profile is cut from the centre of the paper to create two pieces, a positive and negative piece.

7

To help hold this tracing paper onto the surface, several small squares are cut at the top, bottom and sides.

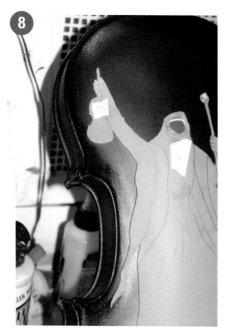

8

These are then covered over with small pieces of masking tape which adhere to the surface. There are still, however, some more delicate parts that will need to be held in place. This can be done simply by applying a very, very small drop of liquid latex to the back of the tracing paper. This latex will act as temporary glue and will not damage your surface in any way.

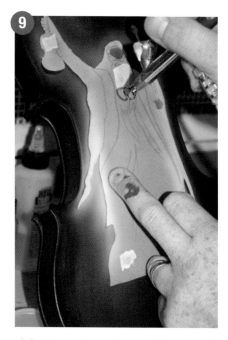

9

White is then lightly sprayed all around the profile of the positive mask. This will become the background of the character. The bottom edge, however, has not been painted at this stage.

10

Using an organic object such as grass or in this case an evergreen leaf, lightly spray over using white. This will give the impression of foreground foliage.

Now all the masking gets swapped around. Place the negative mask back in place covering the background and remove the positive mask. The positive mask will now be cut into smaller pieces determined by your pencil drawing. Here, the face, beard and scarf of Merlin are left exposed. The tracing paper will help create some hard edges for this. Then spray this area white, adding the additional pieces of mask to create edges when required.

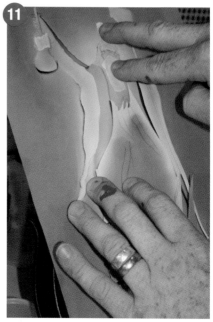

11

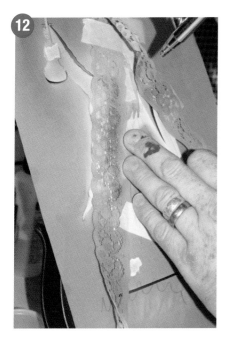

Now tape some lace or even a paper doily over the exposed area. The pattern you have will be transferred as part of the scarf pattern. The more intricate the pattern design, the finer the detail will appear when you have finished spraying. This then gets sprayed black. Try to ensure the lace remains flat to the surface as you are spraying.

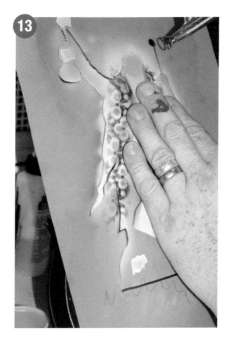

As you can see, the detailing is exquisite, yet took only seconds to paint. The lace is removed and a little more of the black is sprayed to show shadow and tonal definition. The flesh areas are then cut out and sprayed a flat flesh tone.

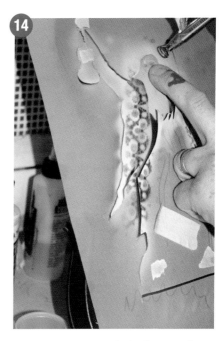

Using a transparent darker brown colour, begin airbrushing in the details such as the eyes, eyebrows, nose and lips. The positive paper mask (face) was carefully cut and sprayed at very close quarters.

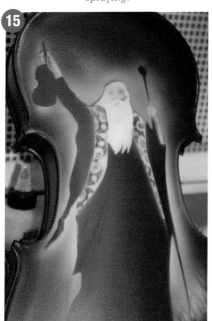

Now all the masking can be removed again. At this stage all the basic forms, shapes and colours are in place.

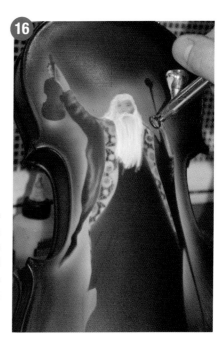

Working with some extra thinned white (an additional 20 per cent water) and at a reduced pressure, begin working in the fine, freehand details for the hair and beard. Any parts of masking that were misaligned can now be hidden and rectified.

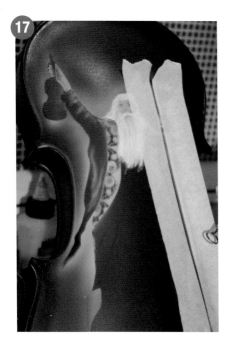

17

Some masking tape is applied to the surface either side of the staff Merlin is holding. Gently spray in some black, primarily on one side. This will help sharpen up the edges of the staff.

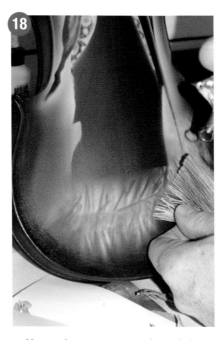

18

Using white again, spray through the edge of a decorator's brush over the foliage section at the bottom of the work. The edge achieved will look like fine grass in silhouette.

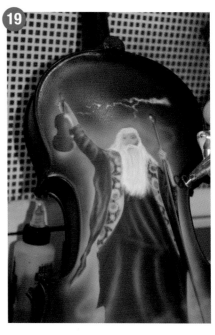

19

Freehand work to the tunic is airbrushed in with white, which is then tinted with transparent blue. Additional freehand work to the sky in the form of lightning and a highlight to the ball at the end of the staff are also completed.

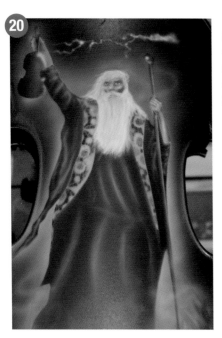

20

Highlights to the face are also completed with a little paintbrush work to the eyes, using white. Additional white highlights are added to the tunic and skin. Our Merlin character is now largely complete.

The next section of the picture begins in earnest. A winged dragon is drawn onto some more tracing paper and the body cut out. This is placed into the correct position and the negative space is sprayed white.

21

Using a manufactured stencil (Dragon Skin by Artimagination Airbrushing), place into a suitable position over the white body and paint blue.

The stencil is then removed and the whole exposed area is sprayed with a transparent green. Here, colours are mixed on the surface as the blue becomes tinted with the yellow to create green.

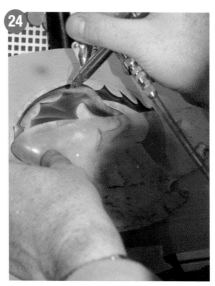

The wings are removed from the stencil and the exposed area is sprayed lightly in white all around the outside edge. Then, using a French curve stencil, airbrush in the wing ribs. These wings are then tinted with transparent blue.

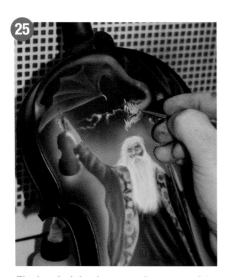

The head of the dragon is then painted in, primarily with a paintbrush. The mouth and teeth are tinted with a little red paint.

Finally, a little more detail is added to the background. (Ideally this should have been done earlier, but on reflection the background looked dull and uninteresting.) Here, a piece of torn tissue is used to create the edges of the clouds.

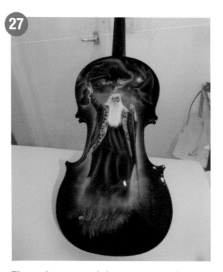

The violin is wiped down again with a tack cloth and set up to receive several coats of two-pack lacquer. This will be allowed to cure overnight before being polished. Two-pack paints are potentially very dangerous and should only be used by professionals or those with specialist breathing and extraction equipment.

Glossary

Acetate: a transparent plastic film that is good for creating stencils.

Acrylic: a modern paint made up of a pigment suspended in a polymer emulsion. It is water based but water resistant when dry. Fast drying, versatile and robust. Available in liquid and paste forms.

Airbrush: a tool that atomizes paint into a mist. Available in various mechanical forms including 'fixed double-action', 'independent double-action' and 'single-action'.

Airbrush paper: a hard paper with properties ideal for airbrushing onto as it does not rip when masking is removed from it. Can be scratched and rubbed (erased) without falling apart.

Air cap: the component of an airbrush that houses a needle and nozzle. Used to deliver compressed air through a small aperture at the front of the airbrush.

Air reservoir: a tank for storing compressed air, often attached to a compressor.

Application tape: a form of very low tack tape usually used with vinyl lettering. Can be used as a form of hard masking for large areas, as it is available in rolls up to 1m width.

Atomization: paint or pigmentation in mist form created from the tip of an airbrush through compressed air.

Background: the part of an image that lies behind the main object. This can be either in or out of focus.

Bar: a metric measurement of air pressure. 1 bar = 14.5 pounds per square inch.

Bottled gas: larger canisters of gas, usually CO_2, to power an airbrush.

Can of air: a small container of compressed air.

Canvas: strong fabric often stretched over a wooden frame, which is ideal to paint onto.

Cleaner: a form of detergent, solvent or spirit in liquid form designed to remove dirt and paint from tools and equipment.

Colour cup: the bowl at the top of an airbrush (gravity fed) in which paint is stored.

Compressed air: the source of power for an airbrush.

Compressor: a machine designed to draw air in and compress it for release under pressure.

Crown cap: also referred to as the needle cap, this part of an airbrush solely protects the protruding needle from damage.

Cutting mat: a plastic mat designed to 'heal' itself when cut with a knife. Protects table tops and other such surfaces from damage when cutting materials such as card, paper and films.

Double-action: the trigger mechanism of the airbrush. A double-action airbrush involves a trigger being pulled back to get the paint. Airbrushes can be either fixed double-action or independent double-action in their trigger mechanism.

Electric eraser: an eraser tip that spins round at high speed enabling fine, accurate, abrasive and very quick removal of paint.

Eraser pencil: an eraser in pencil form. Often available in two forms – hard (white) and soft (pink).

Fixed double-action: the trigger action on an airbrush. This mechanism involves just pulling back a trigger for air and paint. Often associated with spray guns, which also operate using this method.

Food dye: edible colours ideal for airbrushing onto white icing sugar (fondant).

Found objects:	natural and/or organic objects such as coins or leaves, which can be used for masking and template work.
Freehand:	airbrushing without the aid of any stencils or masking.
Frisket:	a clear, low-tack film used for masking. Can be drawn on and cut easily and will achieve a sharp, hard edge. Often referred to as a form of hard masking.
Gouache:	water-based, opaque watercolour. Has good properties to achieve an even, flat colour. Usually available in paste form.
Gravity feed:	paint is drawn downwards using the force of gravity to aid the flow of paint down into towards the nozzle.
Ground:	a surface on which to draw or paint.
Hard mask:	a form of masking that is temporarily fixed to the surface.
Highlight:	the lightest part of an object, where it is most prone to being lit.
Hose:	a hollow tube fixed to your airbrush at one end and an air source at the other.
HVLP	(High Volume, Low Pressure): this relates to the air delivery of a spray gun. Airbrushes usually work on the opposite principle where the volume of air is lower but at higher pressure.
Independent double-action:	the trigger mechanism of an airbrush. This method is the preferred choice of professional airbrush artists as it can offer the greatest control (with practice). The trigger is depressed to release air and pulled back for paint.
Lever:	the trigger of an airbrush.
Liquid:	the state paint and pigmentation should be in to work through an airbrush.
Loose mask:	an unfixed form of masking that can be

	easily removed and replaced.
Mask:	an object, film or tape designed to protect an area of work.
Masking film:	a low-tack clear film. (See Frisket film.)
Masking tape:	low-tack tape in roll form available in various widths.
Medium:	anything that can be sprayed through an airbrush, e.g. paint, pigment or dye.
Moisture trap:	usually as part of a regulator, this device gathers moisture from the atmosphere/air reservoir as it travels to the airbrush. It allows an airbrush to receive clean, dry air.
Needle:	the component in the centre of an airbrush that is used in conjunction with a nozzle to control the flow of paint and quality of atomization.
Negative mask:	a part of a mask that is used to block out an area not needed to be sprayed but leaving an area exposed that is.
Nozzle:	the small part of an airbrush that paint travels though immediately before becoming atomized. Used in conjunction with a needle and aircap.
Opaque:	a paint type that when sprayed can be seen on a black surface.
Overspray:	usually an unwanted area of spray, often caused by inadequate masking.
Plotter cutter:	a piece of technology designed to work with a computer in order to accurately cut masks/templates from a variety of thin materials.
Positive mask:	masking that covers an area that does not need to be painted.
Psi	(pounds per square inch): an imperial measurement of air pressure.
Reamer:	a small, chamfered needle designed to remove dried dirt and debris from inside a

nozzle.

Regulator: an adjustable dial that displays the air pressure being emitted.

Scalpel: a form of craft knife.

Single-action: a simple form of airbrush where the user sets the amount of paint by twisting a wheel at the back of an airbrush, which in turn moves the needle into a set position. Air is introduced by depressing a trigger.

Spray: the paint or pigment emitted from the front of an airbrush.

Spray gun: used to paint larger surface areas with a greater volume of paint.

Soft edge: created using loose masking, sometimes slightly lifted from the surface. Usually achieved through freehand airbrushing.

Stencil: a manufactured mask.

Suction Feed: bottled paint is drawn up through a tube towards the nozzle through the power of the compressed air leaving the airbrush.

Support: another word for ground, a surface on which to paint.

Tack: the 'stick' on the back of frisket film or masking tape.

Tack cloth: a slightly sticky cloth. Used to remove a build-up of dry, surface overspray not stuck to a surface.

Template: a form of loose masking that can either be handmade or manufactured. Another word for stencil.

Trigger: the control on your airbrush designed to help deliver air and/or paint, depending on the type of airbrush.

Vector: computer language that a plotter cutter will understand.

Further information

Books

Charlesworth, Andy. *A Practical Guide to Airbrushing.* (Dragons World, 1990).

Hicks, Roger W. *The Airbrush Book.* (Broadcast Books, 1988).

Leek, Michael E. *The New Encyclopedia of Airbrush Techniques.* (Search Press, 1995).

Maurello, S. Ralph. *The Complete Airbrush Book.* (Leon Amiel Publisher, 1980).

Miller, David, and Diana Martin. *Getting Started in Airbrush.* (North Light Books, 1993).

Owen, Peter, and Jane Rollason. *The Complete Manual of Airbrushing Techniques.* (Dorling Kindersley, 1988).

Shanteau, Pamela. *The Ultimate Airbrush Handbook.* (Watson Guptill, 2002).

Stieglitz, Cliff. *T-shirt Airbrushing.* (Nippan, 1995).

Uccellini, Giorgio. *The Art of Airbrushing.* (Guild of Master Craftsmen, 2011).

Vero, Radu. *Airbrush: The Complete Studio Handbook.* (Watson Guptill, 1983).

Manufacturers and suppliers

Hansa/Harder & Steenbeck (airbrushes and equipment)

Harder & Steenbeck GmbH & Co. KG, Hans-Böckler-Ring 37, 22851 Norderstedt, Germany. Telephone: +49 (40) 87 87 989 30. Website: www.harder-airbrush.de

Iwata Airbrushes UK
The Airbrush Company Ltd, 79 Marlborough Road East, Lancing Business Park, West Sussex BN15 8UF, UK. Telephone: +44 (0)1903 767800. Website: www.airbrushes.com

Iwata-Medea Inc.
1336 N. Mason, Portland, OR 97217, USA. Telephone: +1 503 253 0721. Website: www.iwata-medea.com. Email: info@iwata-medea.com

Badger Airbrush Company
9128 W. Belmont Ave, Franklin Park, IL 60131, USA. Website: www.badgerairbrush.com

Testors (Aztek airbrushes)
440 Blackhawk Park Avenue, Rockford, IL 61104, USA. Telephone: 1-800-837-8677 (1-800-TESTORS). Website: www.testors.com. Email: customerservice@testors.com

Paasche Airbrushes
4311 N. Normandy Avenue, Chicago, IL 60634-1395, USA. Telephone: 773-867-9191. Website: www.paascheairbrush.com. Email: paascheair@aol.com

Chicago Airbrush Supply
2417 N Western Avenue, Chicago, IL 60647, USA. Telephone: +1 800 937 4278. Website: www.chicagoairbrushsupply.com

Artimagination Airbrushing
23 Eastern Avenue, Mitcheldean, Gloucestershire GL17 0DB, UK. Telephone: +44 (0)1594 542030. Website: www.artimagination.co.uk. Email: info@artimagination.co.uk

Vinyl signs and graphics

The Sign Shop UK
Spurside Works, The Downs, Ross-on-Wye, Herefordshire HR9 7TJ, UK. Telephone: +44 (0)1989 769300. Website: www.signshopuk.com

Automotive paint products

Middleton Panels
20 Hempsted Lane, Gloucester GL2 5JA, UK. Telephone: +44 (0)1452 527351. Website: www.middletonpanels.co.uk

Art and graphics products

West Design Products Ltd
West House, Shearway Business Park, Pent Road, Folkstone, Kent CT19 4RJ, UK. Telephone: +44 (0)1303 297888. Website: www.westdesignproducts.co.uk

Createx Paints UK
15 Swanstons Street, Great Yarmouth, Norfolk NR30 3NQ, UK. Telephone: +44 (0)1493 330100. Website: www.createxuk.co.uk

Dr. Ph. Martin's liquid watercolours
The London Graphics Centre, 16–18 Sheldon Street, Covent Garden, London WC2H 9JL, UK. Telephone: +44 (0)20 7759 4500. Website: www.londongraphics.co.uk

Cake products

Sugar Celebrations Ltd
80 Westgate Street, Gloucester GL1 2NZ, UK. Telephone: +44 (0)1452 308848. Website: www.sugar-celebrations.co.uk

Models

Antics Models
79 Northgate Street, Gloucester GL1 2AG, UK. Telephone: +44 (0)1453 825381. Website: www.anticsonline.co.uk. Email: enquiries@antics.ltd.uk

Revell, Inc.
1850 Howard St Unit A, Elk Grove Village, IL 60007, USA. Telephone: 1-800-833-3570. Website: www.revell.com. Email: cservice@revell.com

Index